Focal Digital Camera Guides

Nikon
D60

Corey Hilz

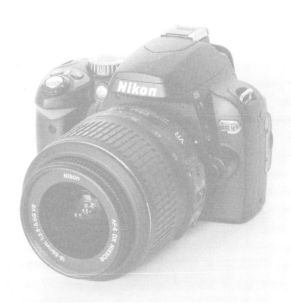

ELSEVIER

AMSTERDAM • BOSTON • HEIDELBERG • LONDON
NEW YORK • OXFORD • PARIS • SAN DIEGO
SAN FRANCISCO • SINGAPORE • SYDNEY • TOKYO

Focal Press is an imprint of Elsevier

Focal
Press

Focal Press is an imprint of Elsevier
30 Corporate Drive, Suite 400, Burlington, MA 01803, USA
Linacre House, Jordan Hill, Oxford OX2 8DP, UK

 Recognizing the importance of preserving what has been written, Elsevier prints its books on acid-free paper whenever possible.

Library of Congress Cataloging-in-Publication Data
Application submitted

British Library Cataloguing-in-Publication Data
A catalogue record for this book is available from the British Library.

ISBN: 978-0-240-81068-3

For information on all Focal Press publications
visit our website at www.books.elsevier.com

08 09 10 11 12 5 4 3 2 1

Typeset by Charon Tec Ltd., A Macmillan Company. (www.macmillansolutions.com)

Printed in Canada

Working together to grow libraries in developing countries

www.elsevier.com | www.bookaid.org | www.sabre.org

ELSEVIER | BOOK AID International | Sabre Foundation

Table of Contents

Introduction

The Nikon D60 is a compact, lightweight, single-lens reflex (SLR) camera. There's a lot packed into this camera, both inside and out, but it can fit easily into your hand and has a comfortable grip. The D60 offers a full set of features for different types of shooting situations. We'll be exploring all the camera's options in this book. In addition to features, an SLR camera gives you access to the full range of lenses from wide-angle to telephoto. Combine the D60 with a telephoto lens and you've got a great setup for action photography. The D60 camera takes photos very quickly with none of the shutter lag you may have experienced with compact digital cameras.

Digital camera technology is always improving and the D60 takes advantage of the latest technology to offer you an excellent set of features, making the camera enjoyable to use. If you were using a compact digital camera before getting the D60 then part of the camera's setup will be familiar. The D60 uses the LCD monitor for accessing most settings. While the setup may be familiar, you'll have access to additional options that can help you take better pictures. For instance, the D60 includes a feature called D-Lighting which helps you capture photos that have more detail in the brightest and darkest areas of your photos. It also gives you more control over the color in your picture. Want to adjust your photos before you get them on your computer? With the D60 it's easy to do! Changing color, cropping, resizing, and converting to black and white are all adjustments you can do right from the camera. A couple of other features to highlight are a self-cleaning sensor and a monitor that automatically rotates when you take a vertical picture.

Whether you plan to photograph people, nature, action or landscapes, at home or abroad you'll find features in the D60 that'll help you capture your best shot. Enjoy!

What's in the Box?

To get started, let's take a quick look at what came in the box with your D60.

- Nikon camera strap. This is a sturdy nylon strap, but if you'd prefer one with more padding take a look at manufacturers that specialize in camera straps, such as OP/TECH USA. The D60 is a light SLR, so you may find the Nikon strap provides enough support.
- USB cable. Used for connecting the camera to your computer or a printer.
- EN-EL9 rechargeable battery

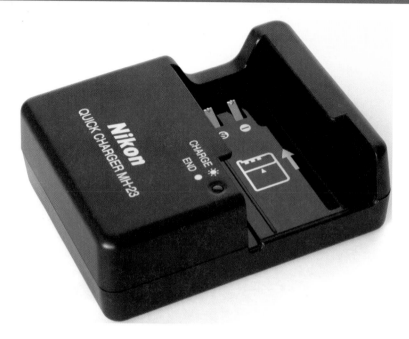

- Battery charger
- Viewfinder cover. Used when doing long exposures to avoid light coming in the viewfinder.
- Manual, Quick Start Guide and Warranty Card
- Software CD for installing Nikon Transfer and Nikon ViewNX

In this section we'll look at all the buttons, dials, and other features on the D60. This overview will help you become familiar with the layout of the camera. I've also included a brief description of each feature. As you read the rest of the guide use these pages as a reference to find a button or as a reminder as to what it does.

FRONT OF THE CAMERA

Autofocus Assist Light

Infrared Receiver

Flash Button

Function Button

Nikon

D60

Lens Release Button

Autofocus Assist Light: Even though the name refers to autofocusing, this light is actually used for a few functions: (1) lighting up subjects to help the lens focus, (2) indicating the self-timer is active, and (3) lighting up before the flash fires to reduce red-eye.

Lens Release button: Use this button when you want to remove or changes the lens. Press the button and hold the camera in one hand. With your free hand, turn the lens to the left to detach it.

Function button: Used as a shortcut button to access certain features.

Flash button: Press this button to release the pop-up flash. You can also use it to increase or decrease the power of the flash.

Infrared Receiver: This dot is what receives the signal from a wireless remote.

INSIDE THE CAMERA

If you take off the body cap on the front of the camera, you'll see a mirror inside. The mirror bounces the light up into the viewfinder, which is what lets you to see what the lens sees. The sensor that records your photograph is located behind the mirror.

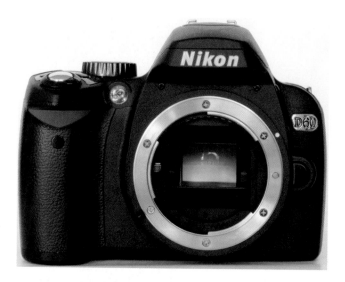

LEFT SIDE OF THE CAMERA

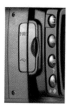

Lift up the cover to access the following connections:

- The top connector is for attaching a video cable to hook your camera up to a television.
- The slot in the middle is the reset switch, which should only be used if the camera stops functioning and other solutions (such as removing and replacing the battery) don't solve the problem.
- The bottom is for the USB cable, which is used to connect the camera to a computer.

RIGHT SIDE OF THE CAMERA

Memory card cover and slot

TOP OF THE CAMERA

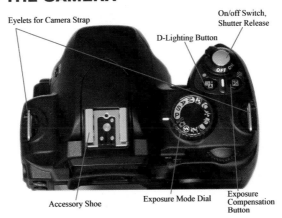

Eyelets for Camera Strap

On/off Switch, Shutter Release

D-Lighting Button

Accessory Shoe

Exposure Mode Dial

Exposure Compensation Button

You'll be using the buttons and dials on the top of the camera frequently. On the left and right sides are two eyelets for attaching a camera strap.

The On/Off switch surrounds the shutter-release button.

The D-Lighting button lets you turn the D-Lighting feature on or off.

The "+/ −"button is the Exposure Compensation button. This is used to increase or decrease the exposure (making an image brighter or darker). There is also an aperture symbol above this button, because in the Manual shooting mode this button is used to change the aperture.

The dial on the top of the camera is used to select the exposure mode.

In the middle is the accessory shoe where an external flash unit can be attached. The D60 comes with a protective cover over the shoe. To remove it, slide the cover toward the back of the camera.

BACK OF THE CAMERA

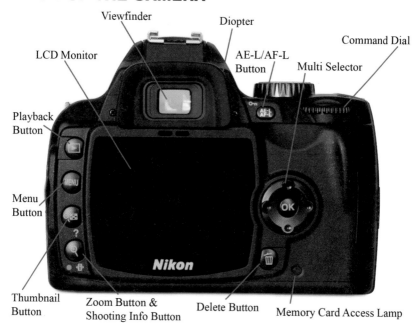

Viewfinder

Diopter

Command Dial

LCD Monitor

AE-L/AF-L Button

Multi Selector

Playback Button

Menu Button

Thumbnail Button

Zoom Button & Shooting Info Button

Delete Button

Memory Card Access Lamp

Viewfinder: Allows you to see exactly as the lens is seeing it.

LCD Monitor: Used to view your photos as well as access the menus and adjust your shooting settings.

Command Dial: Used for changing settings for the exposure modes.

Diopter adjustment: Is an important feature used to make sure that when the lens brings your subject into focus, your subject also appears sharp to you.

Playback button for reviewing images on your memory card.

Menu button for viewing the menus.

Thumbnail button for viewing images as thumbnails and making images smaller during playback. Also accesses the Help information about various camera settings and functions.

Zoom button for making images larger during playback. Also accesses the setting screen for shooting functions.

Delete button for deleting images during playback.

Multi selector for navigating menus and moving between images during playback.

The memory card access lamp lights up whenever the camera is reading from or writing to the memory card.

AE-L/AF-L button is used to lock the autofocus and/or auto exposure readings. This button is also used to protect images from being deleted during the playback mode.

MONITOR INFORMATION

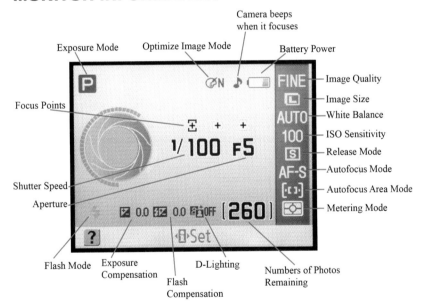

CONVENIENT FEATURES

In-camera help

When you're looking at the shooting information on the monitor or changing a setting in a menu there is often a question mark in the bottom left. If you see the question mark it means you can press and hold the button (notice it has a question mark under it) to display a description of the setting/option you currently have selected. This can be particularly helpful if you need a quick reminder of what a setting does.

Monitor auto turn-off

There are two small sensors directly above the monitor. When you look through the viewfinder the D60 senses something is close to the back of the camera and turns off the monitor. This helps you avoid having to look through the viewfinder with a bright screen under your eye. When you move your face away from the monitor it turns back on.

Auto monitor rotation

The shooting information on the monitor is nicely laid out, but for vertical pictures you'd have to turn your head to read the information. Not so on the D60! When you turn the camera to the vertical orientation the shooting information display automatically rotates as well. You can change settings such as your exposure mode, aperture, shutter speed, and exposure compensation.

Vertical mode.

Horizontal mode.

Quick Start

No doubt you're eager to start taking pictures with your new D60. Don't want to read the whole book just to start taking pictures? Then this is the section for you! You'll learn the basics of your camera and how to start taking good pictures. It covers everything from charging the battery and inserting the memory card to composing and reviewing images.

If you're already familiar with SLR cameras and would like to starting learning in detail about the various options and controls of the D60, you may prefer to skip past this introductory section and start with Part 1.

WHAT DO YOU NEED TO GET STARTED?

- D60
- Charged battery
- Lens
- Memory card

CHARGING THE BATTERY

To set up the charger attach the charger cord to the charger and plug in the cord. To insert the battery into the charger, hold the battery with the side that says Nikon facing up. Slide the battery into the charger so the end with the triangle goes into the charger first. The battery fits completely inside the charger. An orange light on the top of the charger will start blinking continuously. When the charge is complete the light will stay a solid orange. It'll take about 90 minutes to fully charge the battery.

INSERTING THE BATTERY

- Make sure the camera is off before inserting the battery.
- The door to the battery compartment is on the bottom of the camera. Push the lever on the compartment door toward the center of the camera. If you do this while holding the camera upright the door will drop down, opening the compartment.

- Slide the battery into the compartment. (Orienting the battery: Have the side with the word "Nikon" on top and insert the end with the triangle first.) Press the battery door closed.

SETTING THE DIOPTER

The diopter is located to the right of the viewfinder. It's important to set your diopter so you're able to see when your subject is sharp. If it's set incorrectly, autofocus will still focus the lens on your subject, but the subject may still appear blurry to you. You only have to set the diopter once.

Remove the body cap from the D60 (or remove the lens if you've already attached one). Look through the viewfinder and point the camera at something bright so you can easily see the three boxes in the viewfinder. Slide the diopter up and down while looking through the viewfinder until the boxes are sharp.

Note: If you wear glasses when photographing, have them on when you set your diopter. The opposite is also true. If you don't wear glasses when photographing, don't wear glasses when you set your diopter. The diopter is correcting the viewfinder for your vision, so you want to see the viewfinder under the same circumstances as when you're taking a picture.

ATTACHING A LENS

Remove the cap on the back of your lens by turning the cap to the right.

On the back of the lens there is a small white circle along the outer edge. Look for a matching white circle on the camera body, along the edge of where the lens attaches. As you fit the back of the lens into the opening in the camera, line up the two circles. Once the circles are aligned the lens will fit flush with the camera. Rotate the lens to the right until it locks into place.

INSERTING A MEMORY CARD

Make sure the camera is off before inserting the memory card.

The D60 uses a Secure Digital (SD) memory card. The card slot is located on the right side of the camera (when looking at the camera from the back). Open the cover to the memory card slot by pressing and sliding the cover toward the back of the camera.

TIP

Removing the memory card:

Always turn the camera off before removing the memory card. To remove the card, simply press down on the card and it will pop out partway when you lift up your finger.

It's important to orient the card correctly when inserting it into the camera. One corner of the memory card looks as though it has been cut off. The end with this clipped corner goes into the camera first. The side labeled with the name of the card should be facing the back of the camera.

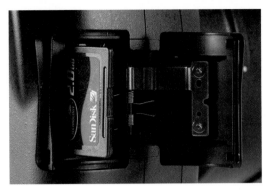

Press the card into the slot until it locks in place.

TURNING THE CAMERA ON FOR THE FIRST TIME

- Around the silver shutter release button is the On/Off switch. Push the switch to the right to turn the camera on.

- As soon as the camera is turned on the LCD on the back of the camera lights up and the camera asks you to pick a language. Highlight the language you would like by using the up and down buttons on the multi selector to the right of the LCD. Once the language you want is highlighted, press the OK button in the center of the multi selector.

- Next select your time zone. Use the left and right buttons on the multi selector to move the yellow stripe to the correct time zone. Press the OK button.

- Choose to have Daylight Saving Time on or off. Press the OK button.

- Set the date and time. Use the up and down multi selector buttons to change the numbers. Use the left and right buttons to move from one number box to the next. Press the OK button when done.

- The D60 will then display "Done" and the LCD will go dark. Your camera is now ready to take pictures!

TIP

How to tell if the camera is on or off:

If the LCD screen goes dark you can't know if the camera is on or off. Near the shutter release button is a vertical white line (between the "info" and "+/ −" buttons). Look at which word is above the line to see if the camera is on or off.

FORMATTING YOUR MEMORY CARD

Before you take pictures using a new memory card you should format the card in the camera. Whenever you want to erase all the photos on the memory card you must format it again.

Press the ⓜ button, then use the multi selector ⊙ to move through the menus. Press the multi selector left to make sure you're in the main menu categories. Then press down to go to the Setup Menu. Press right then down to move over to the Format Memory Card option. Press the ⓞⓚ button to choose it. A warning message will appear to make sure you really want to delete all your photos.

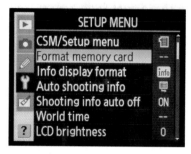
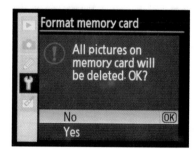

At this point you don't have any photos on the card so you don't have to worry about deleting anything. Select Yes and press the ⓞⓚ button.

This section goes through the steps to get your D60 set up as quickly as possible to start taking good pictures. The other settings and options available will be described in detail later in the book. In subsequent sections I'll also discuss why some settings are better than others, as well as what settings to use in certain situations.

BASIC SETUP

If you've done everything listed in the previous section, Quick Start (charged battery, adjusted diopter, attached lens, inserted memory card) then there are just a few more steps and you'll be ready to start taking pictures.

1. Turn the camera on.
2. Turn the dial on the top of the camera so that "Auto" (in green) is next to the white line.

3. Press the ⊕ button on the back of the camera. This brings up a screen that allows you to change shooting information.

If your monitor doesn't show this screen press the 🔍 button one more time. We're just going to adjust a couple settings here. Use up and down on the multi selector to move to the different options on the monitor.

4. Press the multi selector until the top right box is highlighted in yellow (next to "QUAL").

Press the OK button. A new options screen will appear to choose image quality. Press up or down until "FINE" is highlighted. Fine is the highest setting for image quality.

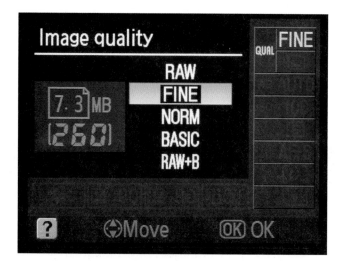

Press OK.

5. Now you're back at the main screen. Press down to highlight the box below "FINE."

Press OK to change the image size. Press up or down until "L" is highlighted. This is setting Large as the size of the image file.

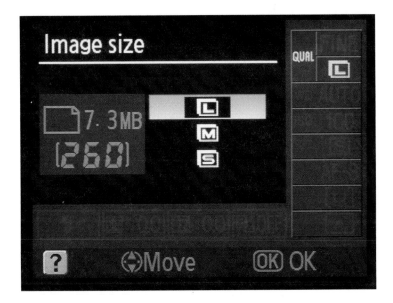

Press OK.

6. Press down to highlight the box below the words "ISO AUTO."

Press OK. Press up or down until "S" is highlighted. Here you're setting the shooting mode to single picture mode.

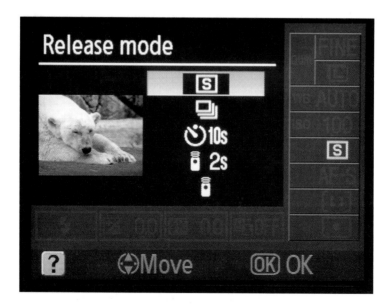

Press OK

7. That's all you need to do here. Press the 🔍 button to exit the settings screen.

HOW TO HOLD THE CAMERA

Your right hand wraps around the right side of the camera. Place your thumb near the dial at the top right on the back of the camera. The index finger on your right hand is used to push the shutter release button, turn the camera on and off, and use nearby buttons.

To best support the camera place your left hand, palm up, against the bottom of the camera. Let your left hand support some of the weight of the camera and lens. Have your fingers reaching out in front of the camera, under the lens. Use your fingers to make adjustments to the lens such as zooming and manual focusing.

COMPOSING AND FOCUSING

- Look through the viewfinder to compose your picture. Use your left or right eye, whichever is more comfortable.
- If you're using a zoom lens, turn the zoom ring to make your subject bigger or smaller in the viewfinder.
- Place your subject in the middle of the viewfinder.
- Press the shutter release button down halfway. This activates autofocus and the subject in the middle should now appear sharp.
- Press the shutter release button down the rest of the way to take the picture.

REVIEWING

Your photo will appear on the back of the camera right after you take the picture. If the monitor on the back goes dark, just press the ▶ button to bring the pictures back. You can look at other photos you've taken by pressing left or right on the multi selector.

DELETING

If you want to delete a photo simply press the 🗑 button and this message will appear:

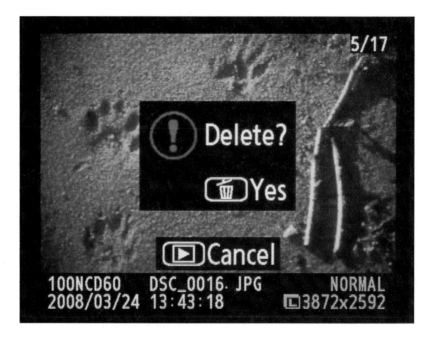

If you pressed the delete button by mistake, press ▶ to cancel.

Press 🗑 a second time to confirm you want to delete the photo.

That's it! You now have the basic settings for a good exposure, you know how to focus on your subject, and you're able to review and delete your photos.

The Camera

Making Pictures

EXPOSURE

Every time you take a picture there are a couple things you want to happen so you get a good picture. You want a good exposure and your subject to be in focus. Whether you choose all the settings on the camera or your camera does it for you, it's important to understand what's controlling how your picture looks.

The exposure is determined by how much light reaches the camera's sensor. A "good exposure" means that your photo is not too bright or too dark. There are two settings that control your exposure: aperture and shutter speed. They also have a big effect on the appearance of the subject or scene you're photographing. The details about these settings can get a little technical, but bear with me. If you understand the general idea of aperture and shutter speed, it will make it easier for you to capture the pictures you want. As we go through this information you'll learn how to:

- Have just one element in focus, such as a flower

- Keep everything in focus, as with a landscape

- Freeze a moving subject, like this chipmunk

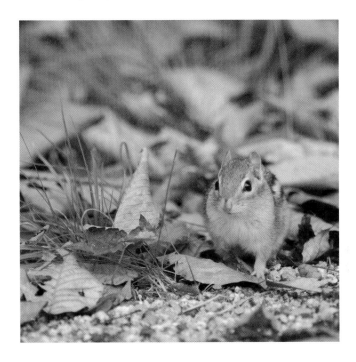

- Blur a moving element, such as a river

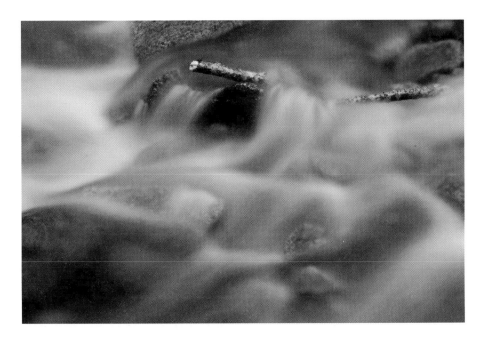

APERTURE

Inside the lens there's an opening called the aperture. This opening controls how fast the light comes into the lens. You can have a very large hole or a tiny one. A big hole is going to let a lot of light into the lens very quickly. With a small hole the light comes in much slower. Every lens allows you to change the size of the opening by changing the aperture setting.

Take a look at these photos to see the actual size of the openings and the number that goes with each one.

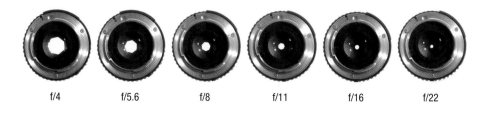

| f/4 | f/5.6 | f/8 | f/11 | f/16 | f/22 |

Notice that each number has an "f" in front of it. When saying an aperture number you also include the "f". For instance f/11 is said "f-eleven." Because of this we also call apertures "f-stops." You can use the terms aperture and f-stop interchangeably. You could ask some-one "What aperture are you using?" or "What f-stop are you using?" and it would mean the same thing.

Now that you know what an aperture is, what does it have to do with your picture? The aperture controls how much of your photo is in focus. Think about photos you've seen where there is just one thing in focus and the background is a blur of color. Now think about a landscape photo where every little detail was in focus. These two extremes of having one element in focus or having everything in focus is the result of changing the aperture.

The wide apertures (large opening) are f/4 and f/5.6. Using these apertures will have just a little bit of your subject in focus. The photo on the next page was taken at f/4. Notice how just one flower is in focus and all the flowers in front of and behind it are out of focus.

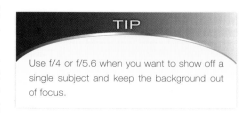

TIP

Use f/4 or f/5.6 when you want to show off a single subject and keep the background out of focus.

The next apertures, f/8 and f/11, are the mid-size openings. These apertures are good for having a moderate amount of your subject or scene in focus. They are good for bringing a group of things in focus, but still keeping the background out of focus. The photo below was taken at f/11. Notice how the mailbox and the window frame are in focus, but the leaves in the background are a little blurry.

The final two apertures, f/16 and f/22, are the smallest ones. Use them when you want to bring as much of your scene/subject into focus as possible. I used f/22 when I took the next photo so that everything would be sharp from the grass in the foreground to the tree line in the background.

TIP

Use f/16 or f/22 for landscape photos when you want the whole scene in focus.

Looking back on what we just learned, does it seem odd that the small number (f/4) refers to a big opening and the large number (f/22) to a little opening? Let me explain since this can be a bit confusing. The f-stop numbers are actually fractions. So "4" is really "1/4" and "22" is "1/22." Now it makes more sense since 1/4 is larger than 1/22. Hopefully this helps straighten things out in your head. It does take some practice to get comfortable with which aperture does what.

DEPTH OF FIELD

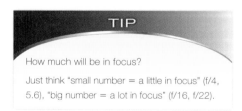

TIP

How much will be in focus?

Just think "small number = a little in focus" (f/4, 5.6), "big number = a lot in focus" (f/16, f/22).

How much is in focus is also called "depth of field." Using a large aperture (f/4) decreases the depth of field (a little in focus). A small aperture (f/22) increases depth of field (a lot in focus).

Here's the same composition photographed at four different apertures.

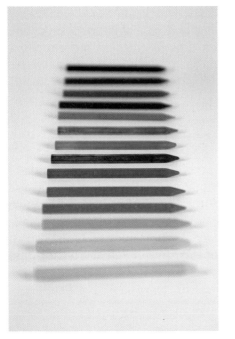

f/2.8

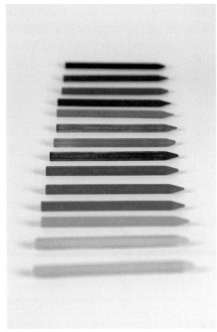

f/5.6

f/11

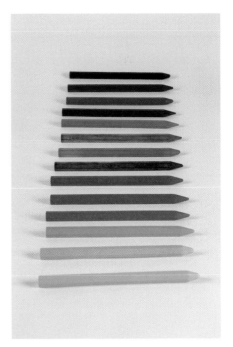

f/22

Using f/2.8 has just one of the crayons in focus. When a smaller aperture is used, more of the crayons are brought into focus. Notice how the area in focus extends in front of and behind the original point of focus (green crayon). When smaller apertures bring more into focus, they do so in both directions (forward and back) from where you focus the lens. Depth of field does not "move" in just one direction. Part of choosing an aperture is deciding how you want your photograph to look. There's no right or wrong aperture to use, it depends on what you want to be in focus.

SHUTTER SPEED

Inside your camera the sensor is covered by the shutter blades. The shutter blades open when you press the shutter release button to take a picture. While the shutter is open, light is reaching the sensor and an image is recorded. The amount of time the shutter blades are open is called the shutter speed.

Light is coming into the camera whenever the lens cap is off, but it can't reach the sensor until you press the shutter release button and the shutter blades open.

The D60 has a range of shutter speeds from very fast (1/4000 of second) to very slow (30 seconds) as shown below.

1/4000
1/2000
1/1000
1/500
1/250
1/125
1/60
1/30
1/15
1/8
1/4
1/2
1
2
4
8
15
30

When the shutter speed is slow it is harder to hold the camera still for the entire exposure. Your subject may not be moving, but if your

hands are moving slightly (called hand shake) then your picture will be blurry. If you find yourself having to use shutter speeds where you can't hold the camera still, it may be necessary to use a tripod. A tripod will hold the camera absolutely still no matter how slow the shutter speed.

BULB SETTING
(ONLY AVAILABLE IN MANUAL EXPOSURE MODE)

After the slowest shutter speed of 30 seconds is the Bulb setting. When Bulb is selected the shutter will stay open for as long as you keep the shutter release button pressed down. Think of the Bulb setting as manual shutter speed. Since you can set the shutter speed for any length up to 30 seconds, you'd use Bulb if you wanted to use a shutter speed longer than 30 seconds. You'll definitely want to be on a tripod if you're using Bulb to ensure the camera stays still.

You can use different shutter speeds to affect how moving objects appear in your photos. To freeze the motion of a moving object you'd choose a fast shutter speed. Using a slow shutter speed would allow you to manipulate the appearance of a moving object by blurring it.

TIP

How to tell if a number is in seconds or fractions of a second.

When you see the shutter speed on your monitor (to the left of the f-stop) and it has quotation marks to its right, then the number is in seconds. No quotation marks means the number is a fraction of a second.

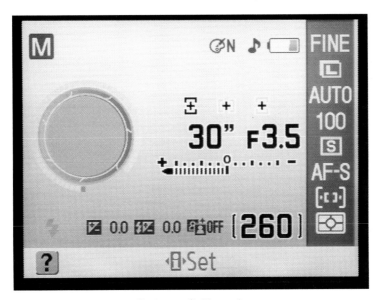

Shutter speed is 30 seconds.

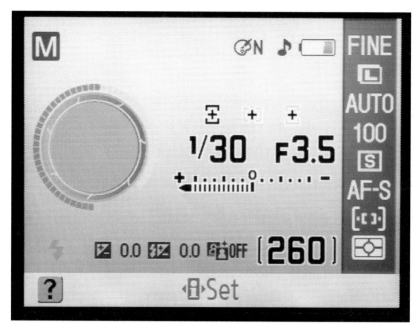

Shutter speed is 1/30 of a second.

Being able to choose different shutter speeds gives you the opportunity to experiment with how you want a moving subject to look. The waterfall photos show how water can be captured in a semi-frozen state or made silky smooth.

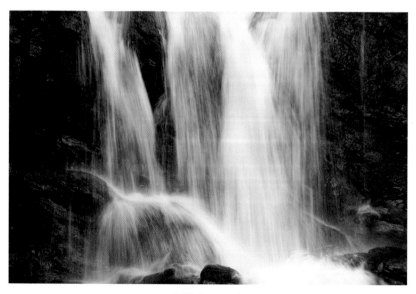

1/13 of a second.

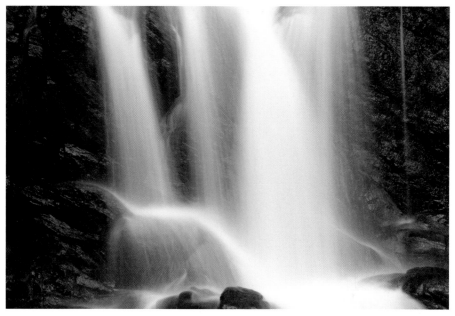

1 second.

Take a look at this series of photos and what shutter speeds were used to capture them.

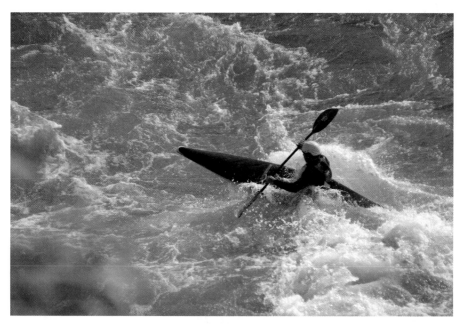

1/1000 of a second
Using a very fast shutter speed allowed me to freeze the action of the kayaker and the water around him.

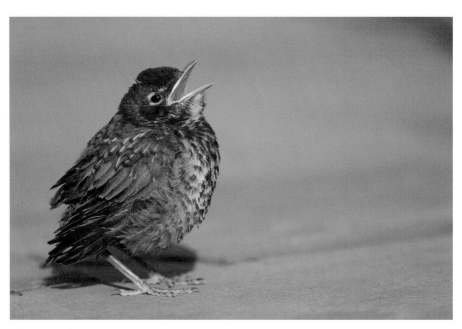

1/640 of a second.
When photographing this young robin a fast shutter speed was necessary to capture the brief instant it opened its beak.

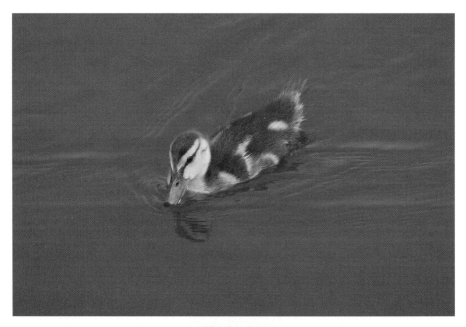

1/200 of a second
As this duck was swimming toward me I needed a fast enough shutter speed to stop its motion. The duck was not moving extremely quickly so 1/200 of a second was fast enough to keep it from blurring.

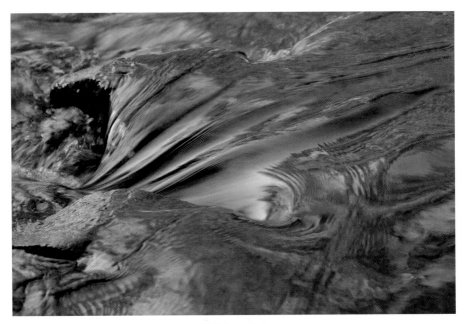

1/25 of a second.
In this photograph of reflections in a river, a slower shutter speed renders a combination of areas that are smooth and others that are distinct.

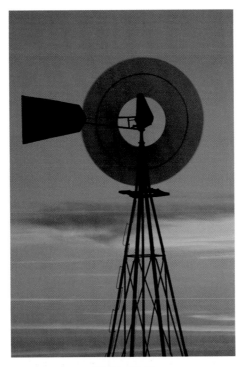

1/3 of a second.
A slow shutter speed of almost a half second allowed me to capture this graphic blur of a spinning windmill at sunrise.

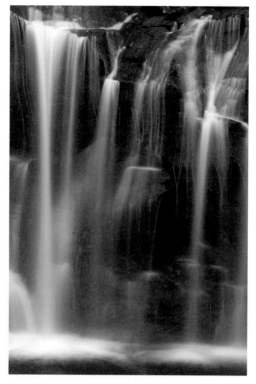

4 seconds.

To make water look silky smooth, often a shutter speed of 1/2 second or slower is necessary. I took this photo in a forest where the lighting was very dim, so an even slower shutter speed was required.

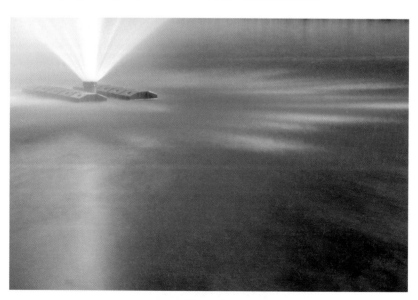

13 seconds.

It was a bright, sunny day when I photographed this fountain. To make the water in the fountain very smooth and blur the slow moving water in the lake, I needed a very slow shutter speed.

EXPOSURE MODES

Now that we have an idea how aperture (or f-stop) and shutter speed affect our pictures, let's look at the exposure modes on the D60. Use the dial on top of the camera to pick one of the exposure modes. As you can see there are a lot to choose from! Let's take a look at each mode, see what options it offers, and when you should use them.

To set the exposure mode turn the dial so that the letter or symbol for the mode you want is lined up with the white line.

AUTO mode is selected.

First a quick overview of the exposure modes. About half the dial has letters representing shooting modes. These are your standard modes. The other modes are represented by symbols. These symbols are specialized exposure modes for taking specific types of pictures:

P — Program

S — Shutter Priority

A — Aperture Priority

M — Manual

Automatic

No flash

Portrait

Landscape

Child

Action

Close-up

Night portrait

PROGRAM

In the Program mode the camera does a lot of the work. It chooses the aperture and shutter speed for you. However, you are still able to control the rest of the camera settings such as white balance, ISO, flash, exposure compensation, and metering. This is a great mode when you want to take a quick snapshot, but still want some choice in what settings the camera uses.

Next we'll look at Shutter Priority and Aperture Priority. Recall that the exposure is controlled by the shutter speed and aperture. With these next two exposure modes you can choose to control the shutter speed *or* the aperture. They're useful modes because they allow you to have a little more control over the picture-taking process, but the camera still does some of the work for you.

SHUTTER PRIORITY

When using Shutter Priority you pick the shutter speed and the camera picks the aperture. This is convenient because you control the shutter speed but the camera still sets the aperture for you. You also have full control over all the camera's other settings.

Shutter Priority is best used when it's important for you to use a specific shutter speed; for instance, you're photographing a soccer game and you need a fast shutter speed to freeze the action. Use Shutter Priority and you can set the shutter speed to 1/500 of a second. Then you'll know the shutter speed will be fast enough.

To use Shutter Priority turn the dial to "S". Press the 🔍 button if the monitor doesn't light up. Then turn the command dial to pick your shutter speed.

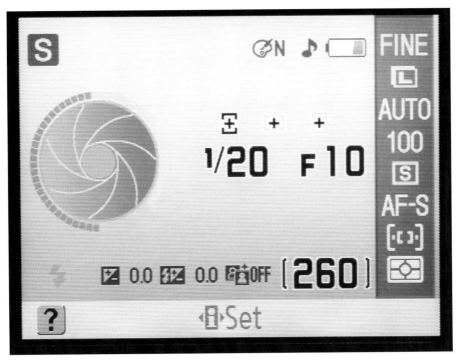

The "S" in the top left corner also lets you know you're in Shutter Priority mode.

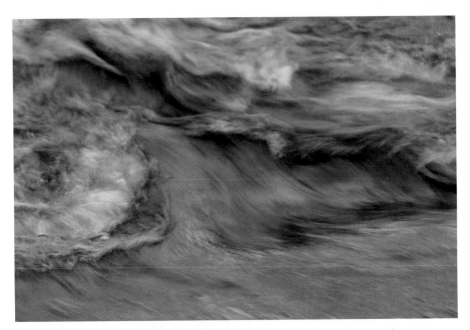

The shutter speed used when photographing moving water makes a big difference in the water's appearance. You can use Shutter Priority to pick the speed you want and know it's not going to change.

APERTURE PRIORITY

When using Aperture Priority you set the aperture and the camera chooses the shutter speed. This is convenient because you get to select the aperture, but the camera still sets the shutter speed for you. You still have full control over all the other camera settings.

As you saw in the photos in the Aperture section, which aperture you choose can make a big difference in the background of your photo. Being able to choose the aperture gives you a lot of creative control over your image. If you're photographing a flower and you want a soft, blurred background, choosing f/4 or f/5.6 will let you achieve this. However, if you use an exposure mode where the camera picks the aperture for you, the camera has no idea what you want the background to look like. Its only concern is a proper exposure, so you may not end up with the type of photo you want.

To use Aperture Priority turn the dial to "A". Press the button if the monitor doesn't light up. Then turn the command dial to pick your aperture.

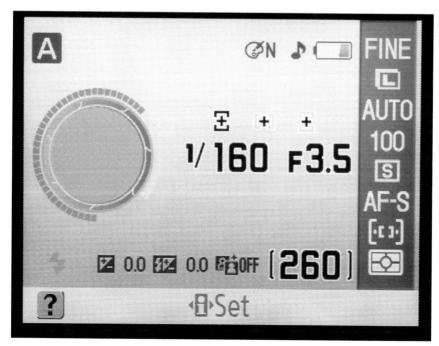

The "A" in the top left corner also lets you know you're in Aperture Priority mode.

Aperture Priority mode is useful when you want to control how much is in focus.

MANUAL

In Manual mode you control *both* the shutter speed and aperture. This is a more advanced exposure mode because the camera is not choosing any settings for you. You might be thinking, how do I know what aperture and shutter speed combination to set? Even though you have to choose the aperture and shutter speed, the camera still provides some information to guide you in the right direction.

To use Manual mode turn the dial to "M". Press the 🔍 button if the monitor doesn't light up. The "M" in the top left corner also lets you know you're in Manual mode. To pick the shutter speed turn the command dial.

To set the aperture you need to use an additional button. Press and hold the 🔲 button while you turn the command dial, now you're changing the aperture.

Next let's look at how to pick the right shutter speed and aperture combination. On the monitor directly below the shutter speed and aperture numbers is a scale with "+" on the left, "0" in the middle and, "−" on the right. This is the Analog Exposure Display.

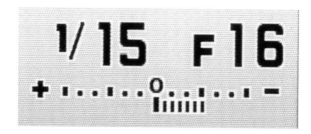

As you change the aperture and/or shutter speed the black lines below this scale will change. The number of lines will change and they'll either be on the left or right half of the scale.

The scale is telling you how your exposure settings (aperture and shutter speed) compare to what the camera thinks is a correct exposure.

A single black line below the zero in the middle means the exposure matches what the camera thinks is the correct exposure.

If the black lines are to the left of the zero, the exposure will be lighter than what the camera thinks is the correct exposure.

If the black lines are to the right of the zero, the exposure will be darker than what the camera thinks is the correct exposure.

When setting your exposure manually first choose the aperture or the shutter speed as your primary adjustment. The idea is to pick the one that gives you the best photograph.

Here are a couple scenarios. You'd want to set the shutter speed first if you're photographing sports so you choose a fast shutter speed.

If you're shooting a landscape, you'd want to set the aperture first so you can pick a small aperture to get everything in focus.

Once you've made that first setting (aperture or shutter speed) leave it alone, and change the other setting. You want to adjust that other setting until there is only one line below the zero. This is a good place to start to check your exposure. Take a picture then look at the photo. Is it too light, too dark, or just right?

- If it's too dark (underexposed) turn the command dial to the left and you'll add lines toward the "+" side. This will make your next picture lighter.
- If the photo is too light (overexposed) turn the command dial to the right and you'll add lines toward the "−" side. This will make your next picture darker.

The more lines you add, the lighter or darker your next picture will be. If your photo is only a little too light or dark, then you probably just need to add a few lines in the appropriate direction. If your photo is way too light or dark, you'll have to add more lines to significantly affect the exposure. After you've adjusted the scale, take another picture and see if it looks better. Continue the process of taking pictures and adjusting the scale until you're happy with how the photo looks. Since it's a digital camera don't worry about taking multiple photos to get the right exposure, you can just delete the ones that didn't work!

AUTO MODES

The D60 offers a standard Auto mode and seven Digital Vari-Programs (represented by the symbols on the Exposure Mode dial).

STANDARD AUTO

The Auto mode is the simplest exposure mode available. The camera controls most of the settings, giving you limited control. The D60 is truly in a "point-and-shoot" mode.

DIGITAL VARI-PROGRAMS

The Digital Vari-Programs are specialized auto modes in which the camera also controls most settings. The settings for each specialized mode are selected for photographing a certain type of subject or scene.

Flash Off.

In the Flash Off mode, the flash will not fire under any circumstances. This can be useful if you're not allowed to use a flash or there is low lighting but you don't want to use the flash. In this mode the camera focuses on the closest subject.

Portrait.

The Portrait mode processes the image to produce soft, natural-looking skin tones. The camera focuses on the closest subject and the flash is in auto mode. If your subject is far from the background and/or you're using a telephoto lens, the background will appear out of focus.

Landscape.

The Landscape mode makes the greens and blues in your scene more vivid. The camera focuses on the closest subject and the flash is turned off.

Child.

The Child mode is useful for quick shots of children. Skin tones are rendered with a soft, natural appearance, while other colors in the photo are vivid. The flash is in the Auto mode and the camera will focus on the closest subject.

Action.

The purpose of the Action mode is to freeze action by using a fast shutter speed. To keep track of a moving subject the camera continuously focuses and the active focusing point will move to follow the subject. The flash is turned off.

Close-up.

Use for close-up pictures of small objects such as flowers, insects, and jewelry. The camera focuses on what is in the center of the viewfinder. The flash is in Auto mode.

Night Portrait

The Night Portrait mode is for photographing a person when there is low lighting. The purpose of this mode is to balance the light on the person with the light in the background. The camera will focus on the closest subject. The flash is in Auto mode, but it will likely fire since you're using this mode in dim lighting. Due to the low light in the background the camera will require a slower shutter. As a result you'll want to have the camera on a tripod so that you get a sharp picture.

The Digital Vari-Programs such as Landscape can make it easy to grab a quick shot while you're traveling.

EXPOSURE MODES REVIEW

Auto mode is best for when you need to take a shot as quickly as possible and want the camera to take care of everything for you. The Digital Vari-Programs are useful Auto modes for photographing specific types of subjects. Program mode gives you more control over your settings, but the camera still picks the aperture and shutter speed for you. Aperture Priority and Shutter Priority are good choices if you're looking to move away from Program or Auto because they allow you to control either the shutter speed or aperture component of your exposure. Manual mode puts you in control of both the aperture and shutter speed.

EXPOSURE COMPENSATION

Does the camera always get the exposure right? No. So what can you do when you take a picture and it's too light or too dark? Use the indispensable exposure compensation setting! Exposure compensation allows you to force the camera to make an exposure that's lighter or darker than the camera thinks it should be. To use exposure compensation press and hold the 🔲 button on the top of the camera. The monitor will light up and display "Exposure comp." to let you know what setting you're changing. While holding down the button, turn the command dial left or right to set the amount of

exposure compensation. Turn the dial to the left to make the exposure lighter, turn it to the right to make it darker. The scale in the center will change, as will the "+/− 0.0" at the bottom. Numbers in the "+" range will make your photos lighter, photos in the "−" range will make it darker. You can also make the same adjustments while looking through the viewfinder. You'll see the same scale and the "+/− 0.0" across the bottom of the viewfinder.

Initially you'll probably use the exposure compensation after you've taken a picture and need to make an adjustment and take the same photo again. Though once you become familiar with how the D60 performs in different lighting situations, you may be able to anticipate when you'll need exposure compensation. In these cases you can set the exposure compensation even before you take the first picture. It'll save you some time and put you closer to getting the shot you want the first time.

Extremes of light and dark can make for challenging exposures. Use exposure compensation to make sure you get it just right.

Here are a few things you'll definitely want to remember about expo-
sure compensation:

- Exposure compensation will only affect the exposure of future pic-
 tures you take. It will not change a picture you have already taken.
 So if you're not happy with how light or dark a picture is, adjust the
 exposure compensation and then retake the photo.
- Exposure compensation will not reset itself automatically (even when
 you turn the camera off). After you take a picture using exposure
 compensation, set the compensation amount back to zero. This is a
 good habit to get into because then you won't be making future pic-
 tures lighter or darker by accident.
- Exposure compensation can only be used in the P, S, or A exposure
 modes. There are no exposure compensation adjustments in the
 Manual, Auto, or Digital Vari-Program modes.
- You will also see this same scale and numbers inside the viewfinder.

Exposure compensation can also be adjusted using the Quick Settings
Display. Press ⊛ two times. Use the multi selector to navigate to the
exposure compensation icon.

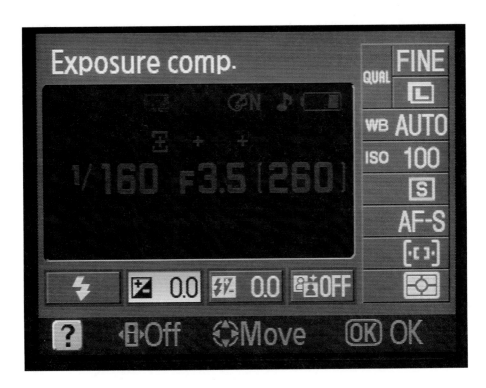

Press OK and you'll be at the exposure compensation screen:

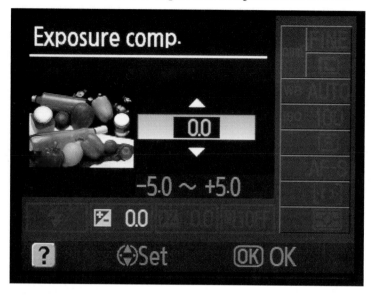

Press the multi selector up or down to select the amount of exposure compensation, then press OK.

IMAGE QUALITY

In addition to selecting the appropriate shooting mode to make sure you capture the peak of the action, the fleeting moment, or the incredible light, you want to also have a high-quality digital image. To select the image quality press the ⊛ button two times. Use the multi selector to navigate to the image quality box.

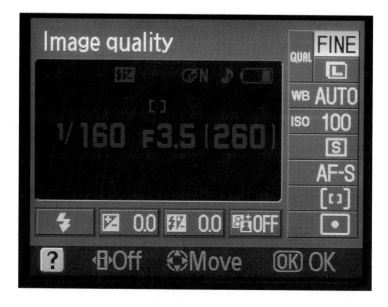

Press OK and you'll be at the image quality screen:

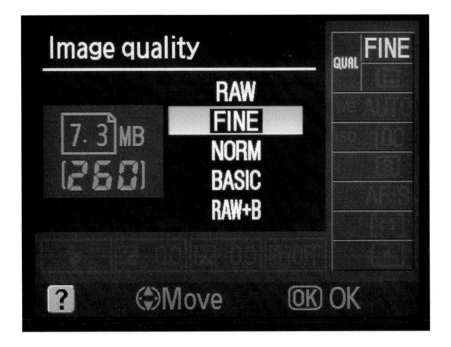

Select the image quality setting you want and press OK.

There are two types of file formats you can choose from on the D60: JPEG and RAW. A JPEG is the common file format for photos. If you've used a compact digital camera it was saving your photos as JPEGs. If the D60 is your first digital SLR camera, then it's likely your previous cameras haven't had the option to shoot in a RAW format. I'll discuss the RAW file format after going over the JPEG quality options.

The JPEG options on the monitor are Fine, Normal, and Basic. Fine is the highest quality JPEG setting and Basic is the lowest. JPEGs have relatively small file sizes because they are a compressed file format. This means when a JPEG is saved some amount of digital information about the photo is thrown away to make the file smaller. Fine JPEGs are compressed a little, Normal JPEGs are moderately compressed, and Basic JPEGs are significantly compressed. The more compressed a JPEG is, the more information is thrown away and the lower quality the resulting image is.

As you move from one quality option to another notice that the numbers to the left change. The top number is the file size for photos taken at that quality level (measured in megabytes; MB). The number below tells you how many more pictures can fit on your memory card at that setting. Fine has a much larger file size than Basic (7.3 MB vs. 1.9 MB).

As a result you can fit many more Basic quality photos on a memory card than you can Fine quality. At first it might seem like a good thing that you can fit many more photos on one memory card. However, that lower file size (which equals more photos) reflects a much lower quality image. If you photographed at the Basic setting the quality of your photos may only be good enough for e-mailing and putting on a Web site. Your printing options would be very limited. I suggest using the Fine setting all of the time to give yourself the most flexibility. You may not be thinking about making a print right now, but it's nice to have the option later on. The hard drives in our computers keep getting bigger, so storing a large number of high-quality photos isn't likely to be a problem.

The last option under Image Quality is RAW+B. Every time you take a picture with this setting the D60 will record a RAW file and a Basic JPEG. Since a Basic JPEG is low quality, the RAW file would be your primary image. A JPEG could still be useful because it's easy to open and quickly review your photos.

If this picture had been taken at the Basic JPEG setting, the quality would be too low to make a nice print to hang on the wall.

A RAW file is a completely different file format than a JPEG. It certainly has its benefits, but there are drawbacks as well. A RAW file is not a standard file format. Each camera manufacturer has its own proprietary RAW format. Nikon's RAW files are called NEFs because NEF is the file extension. For example, DSC_0928.NEF. A RAW file

gives you more control over adjusting your photo after it's on your computer. You can adjust settings such as exposure, contrast, saturation, and white balance and still retain an excellent quality image. You can also bring back detail in areas of a photo that have been over- or underexposed. In comparison, the more significant adjustments you make to a JPEG on the computer, the greater potential for a loss of image quality.

To view and make these adjustments to a RAW file you need software that can read RAW files. In comparison, JPEGs are a common file format so most software programs can be used to view them. A variety of manufacturers make RAW processing programs. Nikon's software is called Capture NX and it is discussed in Part 2. Other RAW processing programs include Aperture by Apple, Lightroom by Adobe, Capture One by Phase One, and Adobe's Camera Raw plug-in for Photoshop and Photoshop Elements. The programs vary in what features they offer, but they can all adjust RAW files. The greatest benefit to RAW files is the level of control you have in adjusting them after the fact. The downside is you need extra software, it requires more time in front of the computer, and the files are larger.

IMAGE SIZE

The Image Size setting is available if you selected one of the JPEG options in Image Quality. Image Size options don't apply to RAW files. To select the image size press the 🔍 button two times. Use the multi selector to navigate to the image size box.

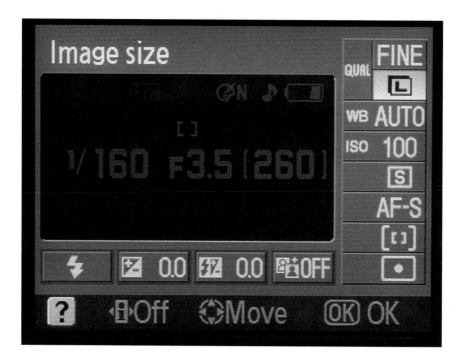

Press OK and you'll be at the image size screen:

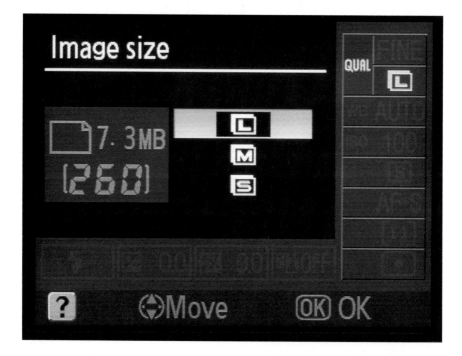

Select the image size you want and press OK.

The Image Size options are Large, Medium, and Small. As with the quality setting, image size also affects what you can do with your photo. With a smaller image size there are less pixels recorded. The fewer the pixels the less information in your picture. This limits how large a print you could make of that photo. Stick with the Large size to retain the most detail in your photo.

ISO

The ISO setting refers to how sensitive the sensor is to light. When we used film cameras we'd photograph with different speed films. ISO is the digital equivalent of film speed. The higher the ISO, the less light the camera needs to make a good exposure. With higher ISOs you can use faster shutter speeds or smaller apertures while still achieving a proper exposure.

SETTING THE ISO

Press the 🔘 button two times to access the settings screen. Use the multi selector to navigate to the ISO box. Press the OK button.

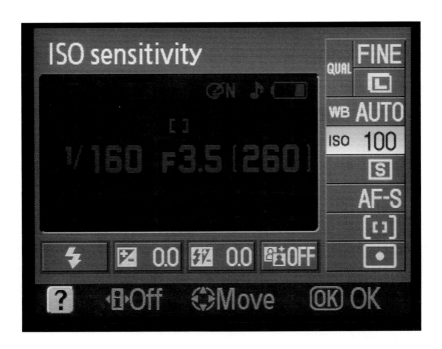

You now have a list of ISO numbers to pick from. Select a number and press the OK button.

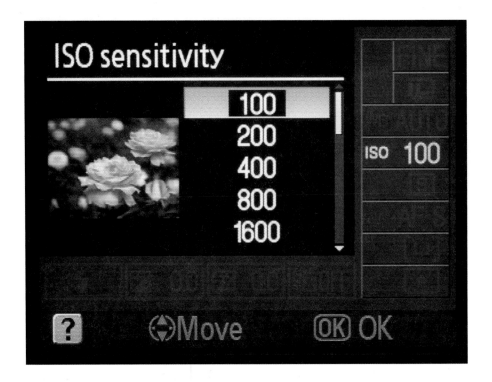

The ISO range goes from 100 to 1600, plus an HI 1 option that is approximately ISO 3200. It might seem like a great choice to always go with a high ISO because then you won't have any problems with freezing moving subjects or using small apertures. Unfortunately there is a downside to using high ISOs. High ISOs cause a loss of fine detail (hair, for example) and give a mottled appearance to areas with a solid color (such as a blue sky). This is called noise. Noise is also more noticeable in dark areas of a photo.

To avoid noise it's best to use the lowest ISO possible. If you're outside on a sunny day photographing landscapes use ISO 100 or 200. If you need to stop fast action try ISO 400. Also if you go inside where the lighting is not as bright, ISO 400 often works well. I would caution against regularly using ISO 800, 1600, and especially HI 1. If you need those high ISOs in certain situations it's great that they're available, but they don't offer the best image quality.

Here's an example of how a higher ISO can allow you to use faster shutter speeds or smaller apertures. Let's say the correct exposure for your picture is f/4 at 1/30 of a second.

Here's how the shutter speed would increase if you used higher ISOs (aperture stays the same):

ISO	Shutter Speed
200	1/60
400	1/125
800	1/250
1600	1/500
HI 1	1/1000

Here's how the aperture would change if you used higher ISOs (shutter speed stays the same):

ISO	Aperture
200	f/5.6
400	f/8
800	f/11
1600	f/16
HI 1	f/22

As you can see from these examples, you could use a significantly faster shutter speed by changing the ISO. This is very important if you're trying to capture kids playing sports or other fast action. On the other hand, you could raise the ISO to use a smaller aperture if you're traveling and want to capture all the detail in a landscape.

At high ISOs noise can be noticeable in dark areas of a picture.

AUTO ISO

The D60 also offers an Auto ISO option. Auto ISO will automatically raise or lower the ISO to help you achieve a correct exposure. This can be a useful setting if you don't want to have to remember to change the ISO when you go from bright light outdoors to dim lighting indoors.

Auto ISO is set through the Custom Settings Menu. Press the ● button and use the multi selector to move down to the custom menu.

There are two other options in the menu: "Max sensitivity" and "Min shutter speed." These settings give you the ability to set some parameters on the ISO as well as shutter speed, which makes Auto ISO more useful. Max sensitivity lets you choose the highest ISO to be used. This is helpful if you don't want the camera to go to ISO 1600 because of noise/quality issues, instead you can set it where it works best for you.

Min shutter speed allows you to set the slowest shutter speed. You can use this setting to make sure the camera doesn't pick too slow a shutter speed for you. If you're hand-holding the camera you may not

want the shutter speed to go below 1/60 of a second, because it'll be harder to hold the camera still enough to get a sharp shot.

METERING

Metering refers to how the camera is reading the light on your subject or scene. The D60 has three metering options that determine how the camera uses this information to set the exposure.

TIP

If you manually set the ISO to HI 1, you won't be able to choose Auto ISO in the menu. Go back and change the ISO to any other number and then you'll be able to access Auto ISO.

To change the type of metering press 🔍 two times. Use the multi selector to navigate to the metering icon:

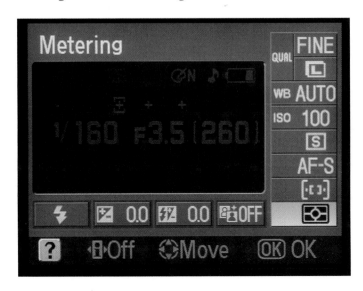

Press OK and you'll be at the metering screen:

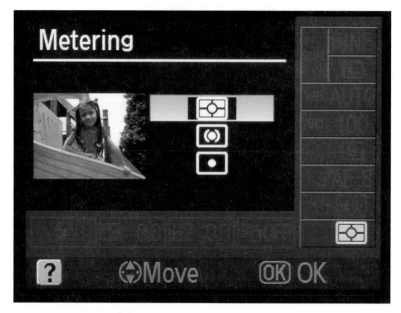

Select the metering you want and press OK.

MATRIX

Matrix metering is a good all-purpose metering setting. The camera takes separate readings of the brightness and color from all parts of the scene in your viewfinder. This allows the D60 to take into consideration areas that are bright, dark, and in between.

CENTER-WEIGHTED

Center-weighted metering places an emphasis on what is in the middle of the viewfinder. The camera takes a reading of everything in the viewfinder, but when calculating the exposure it gives more weight, or importance, to what is in the center of the image. This is a good option for portraits and other photos when your primary subject is in the middle. Particularly if the background is significantly brighter or darker than the subject, center-weighted metering will give more "attention" to your subject, and the exposure won't be thrown off by the background.

SPOT

Spot metering is a very precise metering option. The spot meter reads one small area of the viewfinder and ignores everything else. In the viewfinder there are three focus area boxes. The spot meter reads from whichever one of these is active. To find the active box, lightly press the shutter release button and the outline of one box will light up red. You can press left or right on the multi selector to change which box is active.

With such a bright background the camera's meter could easily be thrown off. Using a spot meter controls what part of the image the camera was measuring.

ACTIVE D-LIGHTING

Active D-Lighting is an adjustment the camera applies to retain more detail in the highlight and shadow areas of your pictures. It can be useful in high-contrast situations where part of the scene is very bright and part is dark; for example, photographing outside with your subject in the shade, but other parts of the scene are brightly sunlit. When Active D-Lighting is on the camera takes a little longer to process the image after a photo is taken, so there will be a noticeable pause before your picture appears on the monitor. Active D-Lighting can be turned on or off from picture to picture.

To turn Active D-Lighting on or off press and hold the 🔲 button on the top of the camera. The monitor will light up and display "Active D-Lighting" to let you know what setting you're changing. While holding down the button, turn the command dial left or right to choose on or off.

You can also access Active D-Lighting through the Quick Settings Display:

Press 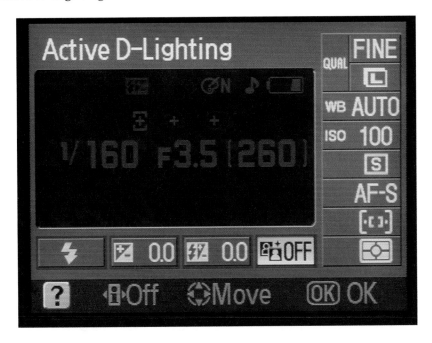 two times then use the multi selector to navigate to the Active D-Lighting icon:

Press OK and you'll be at the Active D-Lighting screen:

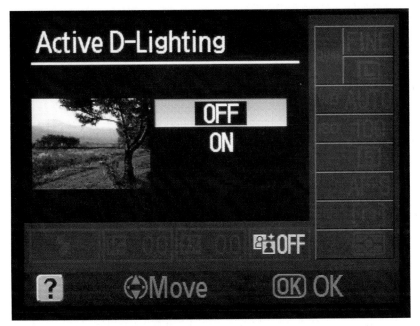

Select On or Off and press OK.

TIP

When using Active D-Lighting in P, S, A, or M exposure modes set your metering mode to Matrix.

RELEASE MODES

There are a few shooting modes to choose from. The different modes give you the option to take pictures one at a time or continuously, as well as the option to use a self-timer or remote control.

To change the release mode press ⊛ two times. Use the multi selector to navigate to the release mode icon:

Press OK and you'll be at the release mode screen:

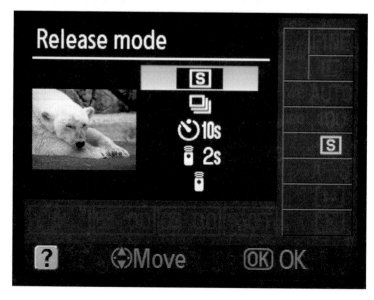

Select the release mode you want and press OK.

⑤ SINGLE-FRAME

In the single-frame release mode the D60 will take one picture each time you press the shutter release button. Even if you continue to hold down the shutter release button, the camera still only takes one picture. To take additional photos you need to lift up your finger and press the button again. This is the shooting mode you'll use for most photos.

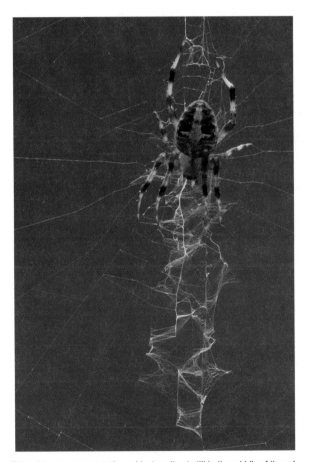

This spider was a cooperative subject, as it sat still in the middle of its web.

🗗 CONTINUOUS

When using the continuous release mode the D60 will take pictures without stopping as long as you keep the shutter release button pressed down. The D60 can capture about three pictures per second. This is a great shooting mode for capturing action. It's difficult to take a single action photo and freeze just the right moment in the action

sequence. By shooting a burst of photos you're more likely to capture at least one good photo in the series.

Shooting a continuous burst gave me a series of photos from which I could pick the best image in the action sequence.

The D60 has a memory buffer that temporarily stores your photos before they are saved to the memory card. In the continuous shooting mode this buffer allows you to continuously take pictures while the camera is saving photos to the memory card. Think of the buffer as a waiting area for photos before they are moved to the memory card. This waiting area only has so much space, so depending on the size of the picture files it could fill up quickly. If the waiting area (buffer) fills up then the camera can't take another photo until it's moved a picture from the buffer to the memory card. If the camera pauses because of this, keep the shutter release button pressed down and the camera will start taking pictures again as soon as it's able.

The good news is if you're shooting JPEGs the buffer is

> **TIP**
>
> Don't use the flash if you want to do continuous shooting. If the flash fires, the camera will only take one picture even if you're in continuous shooting mode. Turn the flash off or choose an exposure mode that won't automatically use the flash.

unlikely to fill up and you won't have any problems capturing a long burst of action. If you're capturing images in the RAW file format, then the buffer can fill up after 4–5 pictures and there will be a lag between photos.

⏱10s SELF-TIMER

The self-timer is useful for self-portraits or group photos that you want to be in. You'll want to have the camera on a tripod or other stable platform. The default timer delay is 10 seconds. You can change the length of the self-timer delay in the Custom Settings Menu (Part 1: Menus). Delays of 2, 5, 10, or 20 seconds are available. After you press the shutter release button, the lamp on the front of the camera will flash as the timer counts down, then stay lit up for the last couple seconds before the picture is taken. If you have the "beep" turned on, the D60 will also beep during the countdown, changing to a rapid beeping just before taking the picture. After a picture is taken in self-timer mode, the camera automatically changes the shooting mode back to the single or continuous shooting mode (whichever was used last). This is useful because you don't have to remember to turn off the self-timer. However, if you want to use the self-timer for more than one picture in a row, you'll need to set it again.

📷 2s DELAYED REMOTE

When the ML-L3 remote (see Part 6) is used in the delayed response mode, the D60 will wait for two seconds, then take the picture. The lamp on the front of the camera will stay lit for the two seconds and the camera will beep (unless the beep option has been turned off). Using a remote makes it easy for you to get into a group picture, then just press the button when everyone is ready. A remote can also be useful for taking a self-portrait.

📷 QUICK-RESPONSE REMOTE

When using the quick-response mode there is no delay. The D60 will take a picture when the button on the ML-L3 remote (Part 6) is pressed. After the picture is taken the camera will beep (unless turned off) and the lamp will flash once. This mode is helpful for avoiding camera shake. Also, it's useful if you can't be right at the camera when taking the picture. For instance, maybe you want to hold a colorful piece of fabric behind your subject. Using the remote you could position the fabric in the background and take the picture at the same time.

A piece of blue fabric was held behind a cluster of flowers to create a colorful background that complemented the subject.

REMOTE ON DURATION

The D60 will wait for a signal from the remote control (Delayed or Quick-response remote modes) for one minute (default setting). If one minute passes and the remote has not been used, then the camera will reset to the single or continuous shooting mode, whichever was used last. You can set a longer period of time before the remote mode is cancelled in the Custom Settings Menu (Part 1: Menus).

CAMERA SHAKE

The self-timer and remote control settings can also be used to reduce the possibility of camera shake. Even with the camera on a tripod, you may slightly shake the camera when you press the shutter release button. This can lead to a lack of picture sharpness even when the subject is in focus. Using the self-timer or a remote ensures that you are not touching the camera when it takes the picture. If you're using the self-timer or delayed remote, make sure your subject isn't moving; otherwise you won't know where the subject will be when the picture is taken.

AUTOFOCUS AREA MODES

In the viewfinder there are three sets of brackets across the middle. Each bracket is a focus area.

When using any of the autofocus modes (described in the next section) the D60 will focus on the subject in one of these brackets. The autofocus area modes control how the brackets are selected. You can also see the brackets on the monitor located above the shutter speed and aperture numbers. These settings have no effect in the manual focus mode.

To select one of the focus areas press left or right on the multi selector.

To change the autofocus area mode press 🔍 two times. Use the multi selector to navigate to the autofocus area mode icon:

Press OK and you'll be at the autofocus area mode screen:

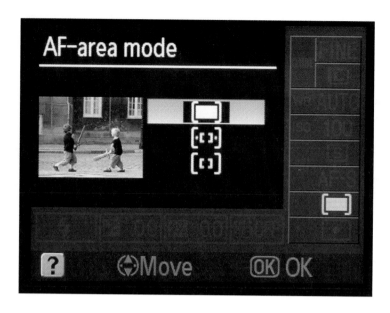

Select the autofocus area mode you want and press OK.

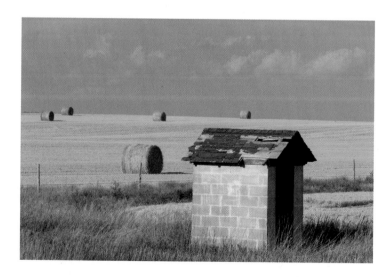 CLOSEST SUBJECT

When using Closest Subject mode the camera automatically selects the focus area with the closest subject in it. Your subject needs to be in one of the three focusing brackets or the camera won't detect it. This mode works well as long as your subject is the closest object to the camera. The camera will adjust focus if your subject moves further away or closer. However, if something comes into the viewfinder that is closer than your subject, the camera may switch the focus to that new element.

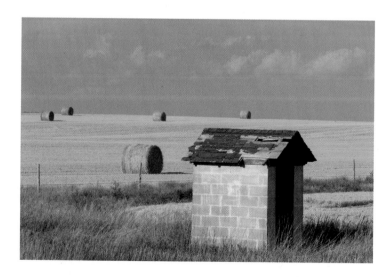

DYNAMIC AREA

Dynamic Area is a great mode for photographing action. You use the multi selector to choose the focus area where your subject is located. If your subject moves out of that focus area the camera will switch to a different focus area to track your subject and keep it sharp. For the dynamic area mode to work effectively, your subject needs to stay somewhere across the middle of the viewfinder. By doing so your subject will be near one of the focus areas.

Closest Subject is automatically selected when you're using any of the following modes: auto , no flash , landscape , portrait , child , or night portrait .

Dynamic Area is selected when you are using the action mode .

SINGLE AREA

In Single Area mode you use the multi selector to choose the focus area. The camera will not change the focus area. This mode is good for subjects that are not moving.

TIP

Single Area is selected when you are using the close-up mode .

The different modes are also indicated by a change in the display of the brackets on the monitor.

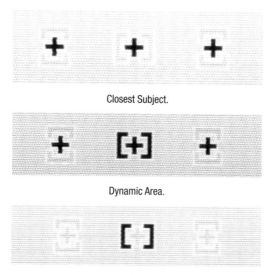

Closest Subject.

Dynamic Area.

Single Area.

You can also find this information in the viewfinder. Take a look through the viewfinder at the information across the bottom. At the far left you'll see a set of symbols similar to what is shown on the monitor.

FOCUS MODES

The focus modes control how the camera focuses on the subject.

To change the focus mode press 🔍 two times. Use the multi selector to navigate to the focus mode icon:

Press OK and you'll be at the focus mode screen:

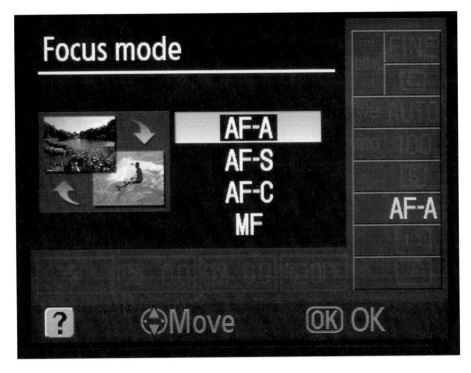

Select the focus mode you want and press OK.

Type of Photo	Suggested Focus Mode
Subject is not moving	AF-S or MF
Action shot	AF-C
Close-up/macro	MF

AF-A AUTO-SERVO AUTOFOCUS

Auto-Servo autofocus mode chooses between single (AF-S) and continuous (AF-C) autofocus modes. The camera will sense if the subject is still or moving, then pick the appropriate autofocus mode.

AF-S SINGLE-SERVO AUTOFOCUS

Single Autofocus is good for subjects that are not moving. Press the shutter release button down halfway to lock the focus on your subject. The D60 will stay focused on the subject as long as you keep the button pressed. Practice pressing and holding the shutter release button to get a feel for how hard to press the button to

lock focus, but not hard enough to take a picture. While you have the focus locked, try pointing the camera at other objects. Point the camera at something behind your subject or even point it at your own feet. You'll notice that the camera doesn't refocus; the focus is still locked on your subject. However, if you or the subject moves (changing the distance from the camera to the subject), the camera won't refocus. If this happens you'll need to lift your finger off the shutter release then press it again to refocus on the subject.

If your subjects are not moving, Single Autofocus mode is a quick and easy way to make sure they're sharp.

AF-C CONTINUOUS-SERVO AUTOFOCUS

Continuous Autofocus is a great focusing mode when photographing something that is moving such as a person or an animal. When you press the shutter release button halfway, the camera focuses on the subject in the active focus bracket. In AF-C mode the camera doesn't lock focus because it will continually refocus as the distance between you and your subject changes. Let's say you're photographing a person. If you walk toward the person the camera will adjust focus to keep the subject sharp. The same holds true if the person walks toward or away from you.

Use Continuous Autofocus to keep a moving subject in focus.

MF MANUAL FOCUS

In Manual Focus mode you control where the camera focuses by turning the focusing ring on the lens. If autofocus can't lock onto your subject try using manual focus instead. Manual focus is also a better choice for close-up or macro photography. When you are photographing something small it is important to be able to precisely place your point of focus. Autofocus often won't "choose" the right place to focus in these situations.

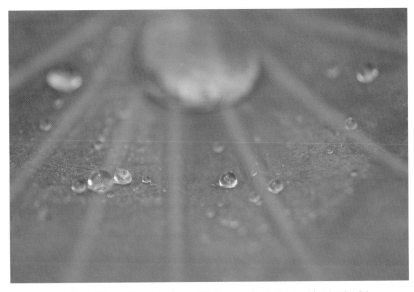

Using Manual Focus allowed me to carefully focus on the first group of water droplets.

FOCUS INDICATOR

In the viewfinder there is a very helpful symbol called the focus indicator. It's a green circle on the far left of the viewfinder. This circle is only visible when something is in focus. When you're using autofocus the camera will beep and the circle will appear when the subject is in focus. Even if the beep is turned off, the circle will still appear to let you know your subject is in focus. If autofocus cannot lock onto what's in the focus bracket the circle starts blinking.

The focus indicator can also be a big help in the Manual Focus mode. You can use the indicator to check and make sure the most important part of your subject is in focus. Use the multi selector to choose the focus bracket that is over your subject. Then turn the focusing ring on the lens until the circle appears. If more than one focus bracket covers your subject, select the bracket that has the most important part of your subject.

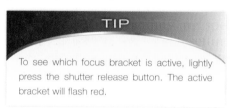

To see which focus bracket is active, lightly press the shutter release button. The active bracket will flash red.

AUTOFOCUS CHALLENGES

Autofocus doesn't work perfectly at all times. Here are some situations when it may not perform as expected:

- Dim lighting: in low light situations there is less contrast, making it harder for the autofocus to lock onto a subject.
- Low contrast: subjects that are one color and have little or no detail, such as a piece of fabric or a wall.
- Fine detail: a repeating subject that is small and does not have a lot of variation, a field of wildflowers for instance.
- Small subjects: if the subject is small enough that it doesn't fill one of the focusing brackets, the camera may focus on the background instead of the subject.

FOCUS LOCK

Sometimes you'll want to compose a picture where the subject is not in one of the three focus areas. So how do you use autofocus to focus on the subject? Use focus lock! Focus lock allows you to make sure the subject is in focus, while still keeping the composition you want. Here's how to do it:

1. Set the Autofocus Area mode to single or dynamic.
2. Place your subject in the active focusing bracket.
3. Press the shutter release button halfway to lock the focus on your subject (check for the focus indicator circle in the viewfinder). As long as

you keep the shutter release button pressed halfway your subject will stay in focus.

4. Recompose to place your subject wherever you want, then take the picture. Now you have the composition you wanted and your subject is in focus.

It can take a little practice to get used to holding down the shutter release button and not accidentally taking a picture. Try practicing at home. Focus on an object, hold the shutter release to lock the focus, and then move the camera. If the focus stays locked on the object then you've got it!

USING THE AE-L/AF-L BUTTON

You can also lock the focus using the ⊞ button on the back of the camera. Follow steps 1–3 above. Then while holding the shutter release button halfway down, press and hold the AE-L/AF-L button. You can now take your finger off the shutter release button, while *still pressing* the AE-L/AF-L button. As long as you keep this button pressed down the focus will stay locked. Recompose. When you're ready to take the picture press the shutter release button all the way down. The benefit of using the AE-L/AF-L button is you don't have to worry about accidentally taking a picture by pressing the button too hard. However, if having to press two buttons seems too complicated just stick with pressing the shutter release button halfway.

Note: When you use the AE-L/AF-L button it also locks the exposure. If you just want it to lock the focus you can change this by going to #12 in the Custom Setting Menu.

WHITE BALANCE

You'll be taking pictures under many different light sources: outside there is sunlight, at home you have lamps, and in an office there may be fluorescent lights. Every type of light has a certain color to it, but when we see things under these various light sources they still appear to be the correct color. A white piece of paper will look white to you whether you see it under a lamp or outside in the sunlight. As the color of the light source changes our brains are able to adapt.

Unfortunately our cameras aren't so lucky. They need a little help to avoid unattractive color casts from the various light sources. Have you ever seen a picture that has a strange color cast to it? Everything

might look overly yellow or have a tinge of green or blue. This is the result of the color of the light having an effect on the entire picture. With film cameras this was more of a challenge because you had to use certain types of film or special filters to avoid these color casts. With digital cameras the white balance setting makes it pretty easy to avoid these potential problems.

To change the white balance press 🔍 two times. Use the multi selector to navigate to the white balance icon:

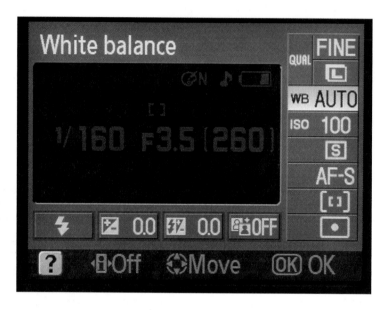

Press OK and you'll be at the white balance screen:

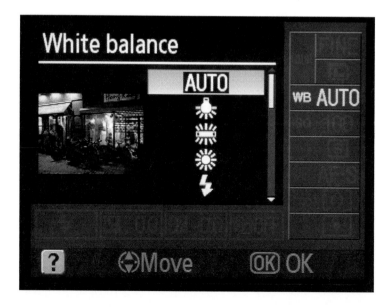

Select the white balance you want and press OK.

There's an auto setting, six settings for specific types of lighting, plus a preset option to set a custom white balance. This might seem like a lot of choices, but picking the right white balance is actually pretty easy. Just ask yourself: "What type of lighting am I under?" Then choose the setting that matches that type of lighting. For example, if you're outside and it's sunny, choose ☀ (direct sunlight). If you're inside your house pick 🔆 (incandescent). When you're using the flash select ⚡ (flash). It's that easy!

MIXED LIGHTING

Sometimes you'll find there is more than one type of light on your subject/scene. Mixed lighting can be more challenging. How do you know which white balance to pick? In these situations Auto White Balance is a good choice because it can set a white balance that takes the different light sources into account.

AUTO AUTO

When using Auto White Balance the camera sets the white balance for you. Like other auto modes, Auto White Balance is convenient because the camera does the work for you. If you go from photographing outdoors to taking pictures inside your house, the camera automatically changes the white balance. The Auto setting might not always produce perfect results. You may photograph in certain lighting situations where it doesn't produce the results you want. This doesn't mean you can't use Auto White Balance. Just remember what those conditions are and choose another setting in those situations.

🔆 INCANDESCENT

Incandescent/tungsten is the type of lighting you'll most commonly find at home.

🔅 FLUORESCENT

Fluorescent lighting is often found in businesses and office buildings.

☀ DIRECT SUNLIGHT

For use on sunny days.

⚡ FLASH

Use the flash setting when your primary light source is the flash on your camera (or an external flash unit).

☁ CLOUDY

On overcast days use the cloudy setting. If you use the direct sunlight setting on a cloudy day your pictures will have a slight blue

color cast. The cloudy setting warms up your pictures to get rid of that blue cast.

SHADE

It may be a sunny day, but if your subject is in the shade you'll want to set your white balance to shade. Shade is a stronger version of the cloudy setting. If the sky is a heavy overcast, the cloudy setting may not "warm up" your scene enough. Try shade for more natural colors.

PRE PRESET WHITE BALANCE

Use preset white balance in the following situations:

1. To set a custom white balance when the other white balance settings aren't producing the results you want; for example, if there is mixed lighting and you're not getting good results from the Auto setting, try setting a custom white balance

> **TIP**
>
> Auto white balance is selected when using the Auto exposure mode or any of the Digital Vari-Program exposure modes. The camera will not allow you to pick a different white balance setting.

> **TIP**
>
> You can also fine-tune each white balance setting through the Shooting Menu (see Part 1: Menus).

2. You want to copy the white balance setting from another photo on your memory card.

These preset options are set through the Shooting Menu (see Part 1: Menus).

To get a feel for how white balance can change a photo let's look at two sets of examples. For each set I've taken the same photograph, but applied different white balance settings to each image.

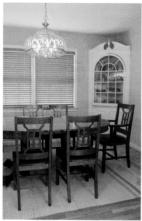

Direct sunlight Cloudy Shade

Incandescent

Fluorescent

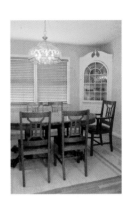

Flash

The photos with the outside white balance settings (sunlight, cloudy, shade) are all noticeably warm. Fluorescent has a light magenta cast. Flash is warm as well because the color of light from a flash is similar to daylight. The incandescent photo is the most natural because the dining room was lit with incandescent light bulbs, even though you may think the sunlight photo makes a room feel more warm and inviting.

Direct sunlight

Cloudy

Shade

Incandescent

Fluorescent

Flash

This photo was taken on an overcast day. The direct sunlight white balance renders the scene a little cool. The cloudy and shade photos both warm it up. Shade has a bit of a yellow cast, and is maybe a little too warm. Incandescent produces a blue color cast; fluorescent a magenta cast. As seen in the previous set of photos, the flash white balance is similar to direct sunlight. Depending on your taste, cloudy or shade would both be good options for this photo.

Part of choosing a white balance setting is personal taste. Should you use cloudy or shade? That depends on how warm you want your subject/scene to be. Perhaps you want to use the cloudy setting on a sunny day to add more warmth to your photo. Maybe you'll use the direct sunlight setting on an overcast day because you like the mood created by the cool tones. Feel free to experiment, you can always delete the photo later!

For more unusual results try using a white balance setting that is completely different than the actual lighting.

Direct sunlight

Incandescent

Fluorescent

For the sunrise image above the true colors are seen when the white balance is set to direct sunlight. The incandescent and fluorescent settings may not be accurate representations, but I think they're also good looking photos! Notice that the incandescent white balance adds a blue cast to the clouds that are gray in the direct sunlight photo. The fluorescent setting adds a magenta cast to the whole image.

FLASH

The built-in flash has different modes for use in different lighting situations. We'll look at what each mode does and when they would be used. Even though the flash has a lot of possible modes, you should be aware that they won't all be available depending on which exposure mode you're using (P, S, A, or M 🏙 🎭 🌃 🏞 🌷).

To change the flash mode press 🔘 two times. Use the multi selector to navigate to the flash mode icon:

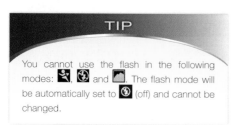

TIP

You cannot use the flash in the following modes: 🏃, 🌙 and 🏞. The flash mode will be automatically set to 🚫 (off) and cannot be changed.

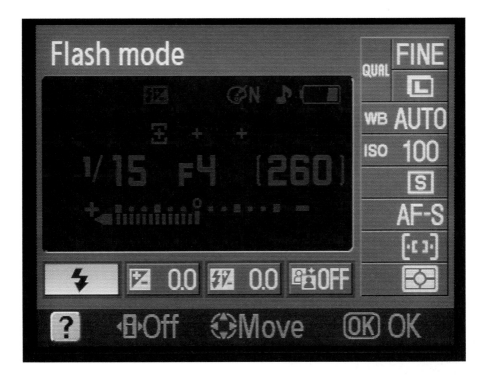

Press OK and you'll be at the flash mode screen:

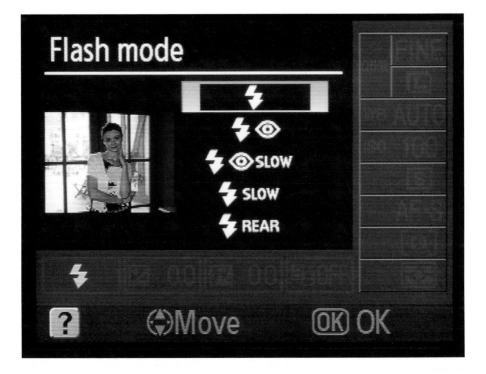

Select the flash mode you want and press OK. As noted above, your exposure mode will affect which flash modes are available.

ALTERNATE WAY TO CHANGE FLASH MODE

Press and hold the flash button on the left side of the camera. The monitor will display "Flash Mode" at the top. All the symbols and numbers on the monitor will be grayed out except for the Flash mode icon in the bottom left. While continuing to press the flash button, turn the command dial.

As you turn the dial the icon for the Flash mode will change.

USING THE FLASH WITH THE 🅰 AND DIGITAL VARI-PROGRAM EXPOSURE MODES

In these modes the flash only pops up if the camera senses there isn't enough light for a proper exposure. In these situations the flash pops up when you press the shutter release halfway. The flash then fires when you take the picture.

DEFAULT FLASH SETTINGS

Auto flash 🔅AUTO is the default for 🖼 🖼, and 🌷.

Auto slow sync 🔅AUTO SLOW is the default for 🖼.

USING THE FLASH WITH THE P, S, A, AND M EXPOSURE MODES

To pop the flash up in these modes you need to press the flash button 🔅 on the left side of the camera. The flash will then fire whenever you take a picture. There is no "off" option in these modes. To make sure the flash doesn't fire press it down until it locks into place.

> **TIP**
>
> In these auto modes you can't manually pop up the flash.

> **TIP**
>
> The avoid the flash popping up (and firing) in these modes, set the flash mode to 🚫 (off).

> **TIP**
>
> If you change the flash mode from the default setting, it will return to the default when you switch to a different exposure mode or if the camera is turned off.

> **TIP**
>
> If the flash isn't used, lower it into the closed position to save battery power. Whenever the flash is up, the camera has to keep it fully charged, which uses up the batteries.

FLASH MODES

🔲AUTO AUTO FLASH

The camera will fire depending on the lighting conditions. The flash will usually fire when the lighting is dim or when the subject is back-lit (the light is coming from behind the subject, causing the subject to be much darker than the background).

🔲 FLASH ON

Flash will fire every time a picture is taken.

🔲 FLASH OFF

The flash won't fire under any circumstances.

◉ RED-EYE REDUCTION

Use red-eye reduction when photographing people. It won't eliminate red-eye in every photo, but it's worth trying. When the D60 attempts to reduce red-eye it lights up the autofocus assist lamp on the front of the camera for about one second before taking the picture. So be aware there will be this lag between when you press the shutter release and when the flash fires/picture is taken. This sequence will happen anytime you see the "eye" symbol next to one of the flash mode symbols.

🔲◉ FLASH ON WITH RED-EYE REDUCTION

🔲◉AUTO AUTO FLASH WITH RED-EYE REDUCTION

🔲SLOW SLOW SYNC

The slow sync mode automatically slows down the shutter speed to capture detail in the background when there is low lighting or at night. This mode is good to use for a portrait in low light. The flash will fire and light up your subject then the shutter will stay open to allow detail to be recorded in the background. If you just used auto flash in this situation your subject would still be well lit, but the background would be very dark or even black. Since you'll be using this mode in low light at slow shutter speeds, you'll want to have the camera on a tripod or other steady platform. Otherwise you'll end up with a blurry picture.

🔲◉SLOW SLOW SYNC WITH RED-EYE REDUCTION

AUTO SLOW-SYNC

The camera determines if the flash is needed. If the camera uses the flash it will be in slow sync mode.

AUTO SLOW-SYNC WITH RED-EYE REDUCTION

REAR CURTAIN SYNC

Normally the flash fires as soon you press the shutter release button. In the rear curtain sync mode the flash fires at the end of the exposure, right before the shutter closes. This mode can be used to create a trail of light behind a moving subject. This mode is best used in low light situations so that the exposure is long enough to give the subject time to move across the frame. If you use rear curtain sync with a fast shutter speed it may not look any different than using auto flash. This is because a fast shutter speed won't give time for the subject to move across the scene in the viewfinder.

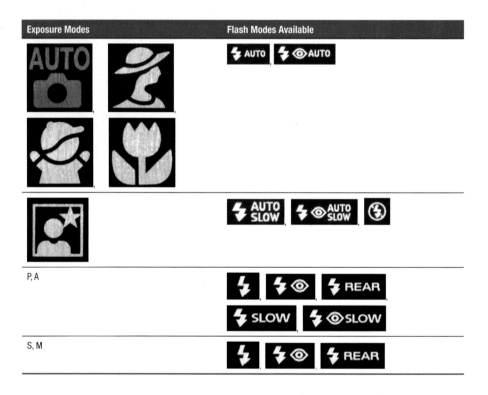

TIP

There is no "off" flash mode for exposure modes P, A, S, or M. To turn the flash off press it down to lock it in the closed position.

TIP

After the flash fires, it must recharge before you can take another picture using the flash. In the viewfinder at the bottom right the flash symbol will blink if the flash is recharging. It will stay solid once the flash is ready to be used.

Flash can be very useful when photographing people in bright sunlight. The flash lightens the heavy shadows resulting in a better looking photo.

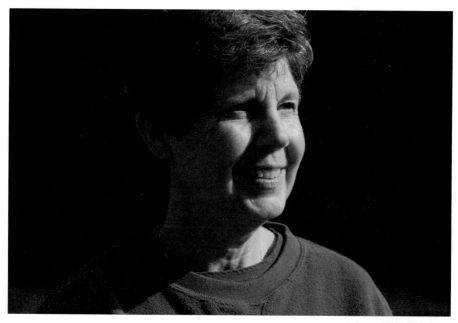

No flash used.

Using flash lightens the shadows on the face.

FLASH COMPENSATION

It's also possible to vary the power of the flash. You can increase or decrease the amount of light the flash puts out by using the flash compensation. The increased power of the flash is not enormous, but it does provide a little extra light if the normal flash power isn't quite enough. The D60 provides more options for decreasing the output of the flash. Flash compensation allows you to balance the light from the flash with the light in the rest of the scene. One of the problems with using the flash at its normal power is that the pictures will look like "flash pictures": the subject ends up very brightly lit, there's often a harsh shadow, and the background may end up very dark. Let's say you're photographing someone outside on a sunny day. The sun is hitting the person's face such that part of the face is brightly lit and the other is a dark shadow. You could use the flash to throw some light onto the person's face to make the light more even and have less contrast. However, you wouldn't want to use the flash at its normal power because the light on the person's face would look unnatural. By reducing the power of the flash you can improve the lighting on the face, but not make it obvious that you used flash. That's the key to successfully using flash: making it look like you didn't use it!

To change the flash compensation ⊛ press two times. Use the multi selector to navigate to the flash mode icon:

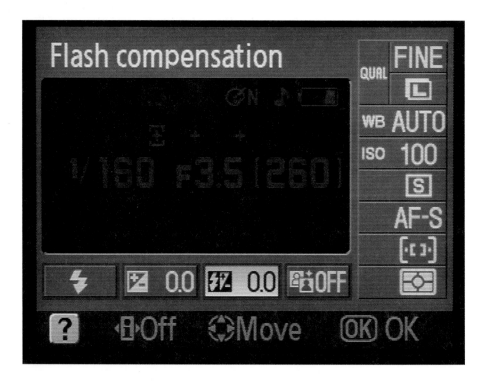

Press OK and you'll be at the flash compensation screen:

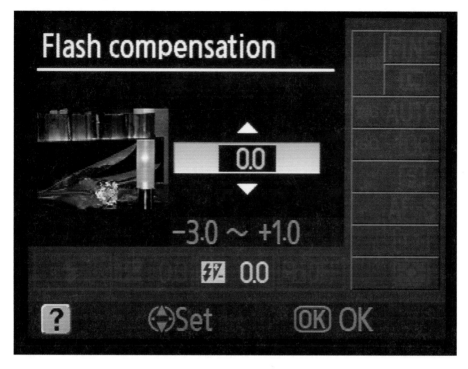

Select the amount of flash compensation you want and press OK. "0.0" is normal flash power. A positive number increases the power of the flash, a negative number decreases the power of the flash.

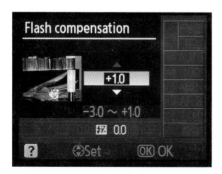
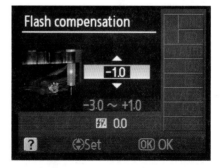

ALTERNATE WAY TO CHANGE FLASH COMPENSATION

This requires pressing two buttons, then turning the command dial. Press and hold the flash button and the exposure compensation button . The monitor will display "Flash compensation" at the top. All the symbols and numbers on the monitor will be grayed out except for the flash compensation icon in the bottom center. While continuing to press these two buttons, turn the command dial.

Flash tips:

- Flash compensation does not reset (return to 0.0) when the camera is turned off.

- When the flash is used at a lower power it takes less time to recharge to be ready to take another picture.

- Increasing the power of the flash will use more battery power and require longer for the flash to recharge.

- Flash compensation can be used to adjust the power of an external flash unit that is in the accessory shoe (SB-400, SB-600, SB-800, and SU-800 flash units).

As you turn the dial the amount of flash compensation will change.

Viewing/ Reviewing Images

To view the photographs you have taken press the Playback button . A photograph will appear on the monitor on the back of the camera. The D60 will display the last photo taken or the last image on the memory card. To exit Playback and switch to Shooting mode press or press the shutter release button halfway.

> ### TIP
>
> While in the Playback mode press the OK button to go to the Retouch menu. Using the Retouch menu you can create an altered copy of the current photo. For details about all the retouch options see Part 1: Menus.

BROWSE IMAGES

Once you have an image on the monitor you can browse through all the photos stored on your memory card.

There are two ways to look through your photographs:

1. Press left or right on the multi selector.
2. Turn the main command dial (located on the back of the camera at the top right, next to the button).

Besides using the Playback mode to look at your photographs, you can use it to find out a lot information about your images. You'll find five screens of information available in the

71

Playback mode. To navigate through the information screens press up or down on the multi selector.

Let's take a look at what each screen tells us:

Basic Info On this screen you see an unobstructed view of your image. At the bottom of the monitor is some basic information about your photo:

- The name of the folder where the image is stored on the memory card
- File name of the image
- Image size (RAW, Fine, Normal, or Basic)
- Image quality (L, M, or S and resolution)
- Date the image was captured
- Time the image was captured

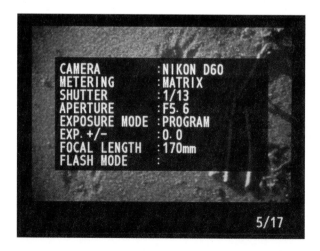

Detail 1 On this screen you'll find details about the exposure and the equipment you used to take the photograph. This information appears in a box overlaid on your image.

You'll find the following information:

- Camera used
- Metering mode
- Shutter speed
- Aperture
- Exposure mode
- Exposure compensation (+/−)
- Focal length of lens used
- Flash mode (blank if the flash was not used)

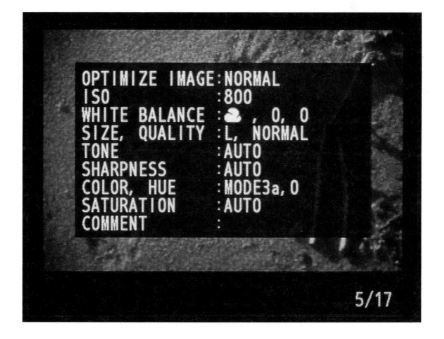

Detail 2 On the second details screen is information about the settings used to capture the image. This info also appears in a box overlaid on your image.

Here's what's listed:

- Image optimization setting
- ISO sensitivity

- White balance mode and any compensation made to the preset white balance (+/−)
- Image size and quality
- Tone
- Sharpness
- Color and hue
- Saturation
- Comment (blank if no comment was added)?

The tone, sharpness, color/hue, and saturation settings can be changed in the Shooting Menu, under Optimize Image.

Detail 3 The third (and final) detail screen just has a couple pieces of information. The info is still in a box overlaid on your image.

Here's what's listed:

- Active D-Lighting: If this feature was on or off
- Retouch: If you're looking at an image created through the Retouch Menu, the type of retouching will be listed.

Highlight On the highlight screen you can see your whole image and at the bottom of the monitor is the word "Highlight."

This an incredibly useful screen because it warns you if parts of your image are overexposed. Any areas that are continually blinking "black then white" are overexposed. A blinking area means that part of the picture is so bright that some details have been lost. To correct for this overexposure use the exposure compensation button ⬛. Set the exposure compensation to a negative number then take the picture again. If there is a small area blinking try an exposure compensation of −0.3 or −0.7. If you have a large blinking area start with −1.0. Recall that exposure compensation only affects future pictures you take, not pictures you've already taken. After taking another photo, check the Highlight screen. If there are still areas blinking reduce the exposure compensation again. Continue this process until there are no more blinking areas.

Histogram The histogram display is a graph of your exposure.

The histogram shows how the light and dark tones in your image are distributed. It's an important tool for evaluating whether your image is too dark or too light. If you are outside on a sunny day or in dim lighting conditions, the image on the LCD may not accurately show you how bright or dark the image actually is.

One important thing to remember is that there is no ideal shape for a histogram. As you look at the histograms for your photos, you'll see them in all sorts of shapes and sizes. Let's take a look at what the histogram tells you. The left side of the histogram represents the shadows and dark tones of your image. The right side represents the highlights and light tones in your photo. In the center are the mid-tones.

Shadows Mid-tones Highlights

Initially you should pay the most attention to the shadows and highlights. When analyzing your histogram take a look at how it's distributed from left to right. The height of the histogram and the shape of the various peaks and valleys are unimportant when determining if you have a correct exposure. There are two main things to look for when reviewing the histogram:

1. You want to avoid having part of the histogram all the way against the right side of the histogram box. This is called clipping the highlights. It means that some of the brightest areas in your image are not just very light, but have become completely white. There is no detail in these areas.

TIP

If you have a histogram that is clipping the highlights, go to the Highlight screen and the areas that are clipped will be blinking.

Loss of detail in the highlights.

2. You also want to avoid having part of the histogram all the way against the left side of the histogram box. This is called clipping the shadows. It means that some of the shadow areas in your image are not just dark, but completely black. There is also no detail in these areas.

Loss of detail in the shadows.

In situations when there is a lot of contrast in your subject or scene (bright highlights and dark shadows), you may not be able to avoid either clipping the highlight or shadow detail. In these cases you have to decide which is more important: keeping details in the highlights or the shadows. I usually choose to hold the detail in the highlights and sacrifice the shadow detail. If your highlights are overly bright they can become a distraction. The bright areas will draw the eye away from your subject because someone looking at your picture may pay more attention to the bright area(s). On the other hand, shadow areas are already dark. So I find it more acceptable to allow them to become a bit darker.

LOSING DETAIL

What does it mean if "details are lost"? Consider if you took a landscape picture with puffy white clouds in the sky. Then you went to the Highlight screen in Playback mode and the clouds were blinking. This means the clouds are now large areas of pure white. The clouds won't look puffy with delicate texture because they've lost all their detail. They'll simply be empty masses of white in your picture.

Let's look at histograms in a little more detail. I mentioned above that the peaks and valleys of the histogram aren't related to correct or incorrect exposure. The height of the peaks show you how much of a certain tonality is in your photograph. As seen in the histogram below, between the highlights and the mid-tones are the light tones; between the shadows and the mid-tones are the dark tones. Looking at the histogram you can tell that the photo it represents has a lot of dark tones because there is a tall spike in that section. There are a moderate amount of mid-tones and smaller amount of light tones, which you can see from the height of the spikes.

Shadows Dark tones Mid-tones Light tones Highlights

Here's the photo for this histogram. As you can see the light and dark areas in the photo match the histogram.

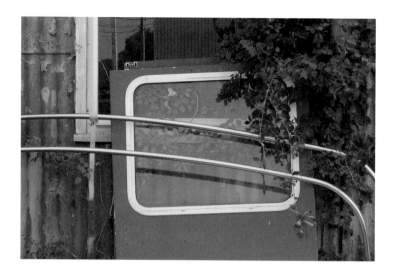

The next histogram has a different arrangement of peaks and valleys. The photo represented by this histogram has many light tones and dark tones, but not many mid-tones.

Shadows Dark tones Mid-tones Light tones Highlights

Here's the photo for this histogram. Once again the light and dark tones in the photo match what is seen in the histogram.

PLAYBACK SUMMARY

The basic info screen is good for viewing your photos and showing them to others. The highlight and histogram screens are useful for evaluating your exposure. These are the two screens I check after taking a photo to make sure the exposure is correct. The two detail screens give you the technical information for your image. This may be more information than you ever want to know about your photos, but it's there if you need it! This information is actually part of the image file that is saved on your memory card. Using the software we'll look at in Part 2 you can see this information again after you put the pictures on your computer. This is convenient, because at a later date you may want to look up a certain setting such as what aperture you used or what the ISO was set at. You can even find out on what date you took a photo. No need to remember when you visited a certain place, you can just use the software to look up the date for a photo you took there.

DELETING PHOTOS

While in Playback mode you can delete photos by pressing the trash button 🗑. The following message will appear to confirm that you do want to delete that photo:

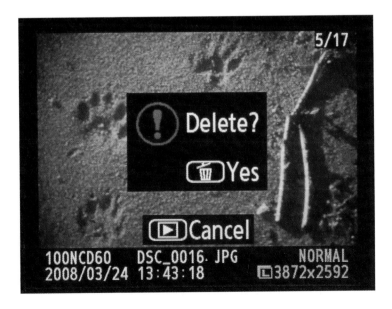

Press 🗑 again to delete, press ▣ to cancel and return to your photo.

PROTECTING PHOTOS FROM DELETION

If you want to make sure you don't accidentally delete a particular photo, press the 🔘 button while in Playback mode. A key symbol will appear in the top left of the photo.

TIP

Protected photos will be deleted if the memory card is reformatted.

The camera won't let you delete a protected photo. To remove the protection press 🔘 a second time and the key will disappear.

ZOOMING IN

To zoom into your photos during playback press the 🔍 button. Each press of the button will zoom in further until you are looking at a very small part of your photo. To zoom back out press the 🔍 button.

As you zoom in or out a thumbnail of the entire image appears on the monitor. The yellow box shows you what part of the image you're looking at. To see different areas of the magnified photo press left, right, up, or down on the multi selector. The yellow box will move as you press the multi selector to help you navigate around the photo.

Viewing different parts of the magnified photo.

If you don't press any buttons for a couple of seconds the thumbnail image will disappear. It will reappear once you zoom in or out or use the multi selector to move around the photo.

The zoom feature is great to use to see the details in your photos. However, when making critical decisions about image sharpness, I don't recommend using it to choose which photos to delete. On one hand, if a photo is significantly out of focus that will be easy to see. On the other hand, if a photo doesn't appear sharp, I wouldn't delete it based on how it looks on the monitor. Wait until you can see the photo on your computer to make a final determination. Your computer monitor is much better quality than the D60's monitor and will allow you to better assess sharpness.

TIP

To move quickly around the image press and hold the multi selector in the direction you want to move.

TIP

Turn the command dial ▨▨ while zoomed in and you will switch to a different photo, but stay zoomed in the same amount. This can be helpful if you took multiple photos of the same composition and want to compare the same detail in each photo.

VIEWING MULTIPLE PHOTOS

To switch to the thumbnail view press ▨. The monitor will show four photos.

Press again and you'll have nine photos.

Use the multi selector or command dial to move to different photos. The thumbnail view makes it easier to scroll through lots of photos to find the one you want.

> **TIP**
>
> In thumbnail view press (OK) to immediately bring the selected image to full-frame view.

If you're zoomed in on an image, you'll need to press repeatedly to zoom out, then the monitor will switch to thumbnail view.

SLIDE SHOWS

You can use your D60 to run a slide show of the photos on your memory card. The slide show feature is an easy way to show your photos to others and not have to manually go through all the images. The slide show is accessed through the menu. Press the button. The slide show settings are located in the Playback menu. Use the multi selector to navigate to Slide Show.

There are a couple options in the slide show menu:

1. **Start:** Press to begin the slide show immediately.
2. **Frame Interval:** The frame interval is the amount of time each photo is shown before going to the next one.

While the slide show is playing you can pause it by pressing ⓞⓚ.

In the menu that appears, use the multi selector and press ⓞⓚ to make your choice. You can resume or exit the slide show (exiting takes you back to the menus list). You can also change the frame interval.

There are a few more options available during the slide show:

- **Skip forward or back:** Using the multi selector press right to go forward and left to go back.
- **Change the shooting information screen shown (details, histogram, highlight, etc.):** Press up or down on the multi selector.
- **Exit the slide show:** Press any of the following buttons:

 Displays shooting information

 Switches to the Playback mode (thumbnail or full image view)

 Returns to the Playback menu

 Press halfway down to switch to shooting mode. The monitor goes dark and you're ready to take a picture.

VIEWING PHOTOS ON TV

You'll need an EG-D100 video cable to connect your D60 to a television or VCR. This video cable isn't included with the camera and must be purchased separately. First you'll go to the Video mode through the menus. Press the ⓜ button. The slide show settings are located in the Playback menu. Use the multi selector to navigate to Slide Show.

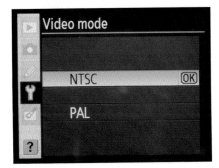

TIP

Always turn off the camera before connecting or disconnecting the video cable.

1. Choose the correct video mode. NTSC is used when connecting the D60 to an NTSC television or VCR. Use PAL if you're connecting to a PAL video device.
2. Turn off the camera.

3. Connect the video cable. The video connection on the D60 is under the door on the right side of the camera. Plug the cable into the top opening.

4. Set the television to the video channel.
5. Turn on the camera and press the button to start playing your photos. During the playback the images will appear on the television or be recorded on video tape. The monitor on the D60 won't turn on.
6. Turn the camera off to stop playback.

Menus

Pressing the Menu button 🔘 brings up the main Menu screen on the monitor. There are five menu groupings, each represented by an icon down the left side of the monitor: Playback, Shooting, Custom Setting, Setup, and Retouch.

NAVIGATING THE MENUS

To navigate to the different menu groups press the multi selector left. Now one of the icons for the menu groups will be outlined in yellow.

Press the multi selector up and down to move between menu groups. To move over to the options for any group press the multi selector right. Now you are in the options section for a particular group. Press the multi selector up and down to highlight a setting. Then press the OK button to see the options for that setting.

There's one menu setting we need to check before we start going through

TIP

If you are changing one of the settings and decide you really don't want to change to that setting, you can always press the Menu button to immediately return to main menu list (no change will be made to the setting you were just in).

TIP

Some of the settings in the menus can also be changed through the Quick Settings Display (press 🔍 twice to get to it). I think it's more convenient to use the Quick Settings Display because it's easy to access and you don't have to look through menus to find the settings. I've noted in the information for each menu item whether you can access the setting through the Quick Settings Display.

the menus. Go down to the Setup Menu. Press the multi selector right to choose CSM/Setup menu.

Bring up the CSM/Setup menu by pressing right again on the multi selector. Highlight "Full" by pressing the multi selector up or down. Once Full is selected press OK. This makes sure that every option in all the menus will be available. We'll come back to this menu later to look at the other options.

PLAYBACK MENU

The Playback Menu adjusts settings related to when you are viewing your photos.

DELETE

In Part 1: Viewing/Reviewing Images you learned how to delete photos in the playback mode using the 🗑 button. You can also delete photos through the Playback Menu. Using the Playback Menu is a faster way when you want to delete a lot of photos at once.

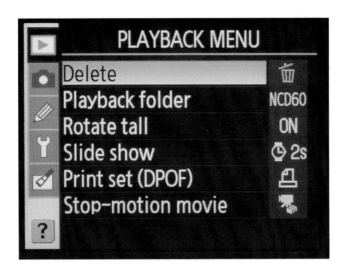

You can choose to delete specific photos or all your photos at once. If you choose to delete selected photos, you'll see thumbnails of your images.

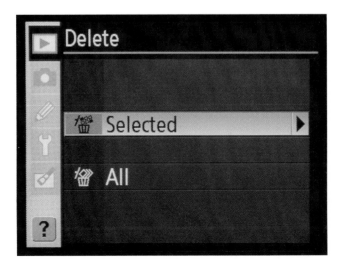

Use the left and right of the multi selector to navigate through the thumbnails. To make one of the thumbnails larger press and hold the Zoom button. When you release the Zoom button you're back to the thumbnail view.

When the yellow box is surrounding a photo you want to delete, press up or down on the multi selector. A trash can icon will appear in the top right corner of the thumbnail. This image is now marked to be deleted.

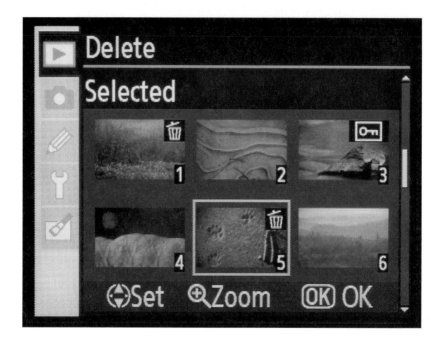

If you change your mind, simply press up or down again and the trash can will be removed.

Once you've marked all the photos you want to delete press the OK button. The camera will confirm you want to delete the photos whether or not you selected photos or all photos.

If you decide you don't want to delete any photos, press the Menu button. Even if you had thumbnails marked with the trash can, nothing will be deleted.

Whenever you choose to delete photos (one or all) you'll be asked to confirm if you really do want to delete the photo(s). While this adds an extra step, it also protects you from deleting a photo accidentally.

PLAYBACK FOLDER

The camera stores your photos in folders on the memory card. By default there is a single folder named NCD60. If you would like to create additional folders there is a "Folders" setting in the Setup Menu.

This setting designates which folder of images you'll see when you playback your photos. You have the choice to play back images from the current folder or all folders.

ROTATE TALL

Rotate Tall controls whether vertical photos (portrait orientation) are rotated during playback. "On" means vertical photos will be shown correctly during playback. "Off" means vertical photos will be shown sideways and you have to turn the camera to view them. The trade-off is that with the "Off" setting your vertical photos will be larger on the monitor, but you have to turn the camera. With the "On" setting you won't have to turn the camera, but your vertical photos will be smaller.

SLIDE SHOW

A quick way to share the photos on your memory card is to run a slide show. It's a lot easier than repeatedly pressing the multi selector in playback mode if you want to show a lot of pictures.

Frame interval allows you to choose how long each photo will be displayed.

There are a number of options available while the slide show is playing:

- Skip back/skip ahead
 - Left on the multi selector goes to the previous photo.
 - Right on the multi selector skips to the next photo.
- Display shooting information
 - Press up or down on the multi selector to display different screens of information about the photo.
- Pause slide show
 - Press OK button. Options appear to restart the slide show, change the frame interval, or exit the slide show.
- Return to Playback *Menu*
 - Press Menu button. The slide show ends and you're taken back to the Playback Menu (same menu where you started the slide show).
- Go to Playback *Mode*
 - Press Play button. Exits slide show and changes to Playback Mode. If you were in the thumbnail view before the slide show, the thumbnails will return. If you were in the full-frame view, nothing will appear to change, but you're in Playback Mode. Use the multi selector to move through the photos or view the shooting information.
- Go to Shooting Mode
 - Press shutter-release button halfway to exit the slide show and switch to Shooting Mode.

PRINT SET (DPOF)

Print set allows you to select photos that you want to print directly from the camera.

Choose "Select/set" and you'll see thumbnails of the photos on your memory card.

Use the left and right of the multi selector to navigate through the thumbnails. To see one of the thumbnails in full-frame view press and hold the Zoom button. When you release the Zoom button you're back to the thumbnail view.

When the yellow box surrounds a photo you want to print, press up on the multi selector. A printer icon and "01" will appear in the top right corner of the thumbnail. The number indicates how many copies of the photo will be printed.

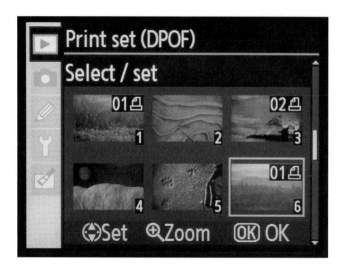

Press the up multi selector to increase the number of photos to be printed. Press the down multi selector if you don't want to print that photo. After making your selections press the OK button. You now have the option to have information printed on the photo. Data imprint is shooting information (aperture, shutter speed) and imprint date is the date the photo was taken.

At any time you decide you don't want to print a photo, press ⬤.

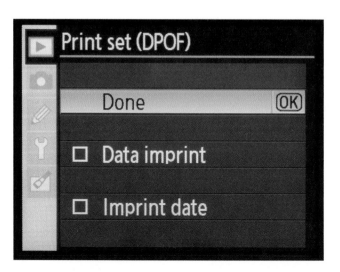

After making any selection here, press OK and your print order will be saved. When you're ready to print take the following steps:

1. Turn the printer on.
2. Turn the D60 off.
3. Connect the D60 to the printer using the USB cable that came with the camera.
4. Turn the camera on.
5. The PictBridge screen will appear and you'll see a photo from your memory card. Press the button and choose "Print (DPOF)" to print the set of photos you've already selected. You can also choose "Print select" to choose different photos to print. The index print option will print small thumbnails of your pictures with many photos per page. It will also print all of the JPEG photos on your memory card (up to 256).

TIP

You can only print JPEGs with the Print Set method. You won't be able to select RAW (NEF) files for printing. You can use the Quick Retouch or NEF (RAW) Processing options in the Retouch Menu to create a JPEG from a RAW file. You would then be able to print the photo using Print Set.

STOP-MOTION MOVIE

Stop-motion movie is the last item in the Playback Menu. If you have created a stop-motion movie in the Retouch Menu you can select your movie here and play it.

SHOOTING MENU

The Shooting Menu lists settings that are used when you take a picture.

OPTIMIZE IMAGE

The optimize image options give you the ability to fine tune how the colors, contrast, and sharpness of your subject are captured by the camera.

If you're happy with the color, contrast, and saturation in your pictures then you can leave Optimize Image on the Normal setting. It's only if you're unsatisfied with the results that you'd want to consider one of the other settings. Keep in mind that if you change the setting, it will affect every photo you take. The Vivid setting might make your landscapes more vibrant, but people pictures might not look so great.

Normal: Works well for most photography.

Softer: Outlines of your subject are softened and contrast is reduced. Try using it for people photography.

Vivid: Increases saturation, contrast, and sharpness. Particularly emphasizes reds, greens, and blues. Best used for nature photography.

More vivid: Further increases saturation, contrast, and sharpness beyond what Vivid produces.

Portrait: Portrait reduces contrast and softens skins tones.

Black and white: Images are all taken in black and white.

Custom: Allows you to fine-tune individual settings.

Choosing the Custom Optimize Image screen gives you the ability to individually set the sharpening, contrast, color mode, saturation, and hue.

- Image Sharpening: Makes images appear sharper by adding more definition between light and dark areas.
- Tone Compensation: Controls the amount of contrast.
- Color mode:

 Ia — sRGB color space, good for portraits that you don't plan to further adjust on the computer.

 II — Adobe RGB color space, it offers a wider range of colors than sRGB, making it a better choice if you plan to adjust/retouch your photos on the computer.

 IIIa — sRGB color space, colors are geared toward nature and landscape photos that you don't plan to further adjust on the computer.

TIP

If you pick Auto for any of the settings in Custom Image Optimization the appearance of your photos may vary from picture to picture. To keep consistent results choose a setting other than Auto.

- Saturation: Controls how vivid the colors are.
- Hue Adjustment: Affects the appearance of colors overall, introducing slight shifts in color. Negative numbers add a little more red, positive numbers add a little yellow.

IMAGE QUALITY

Image Quality lets you choose if you want to shoot a JPEG or RAW file, as well as select the quality level of the JPEG.

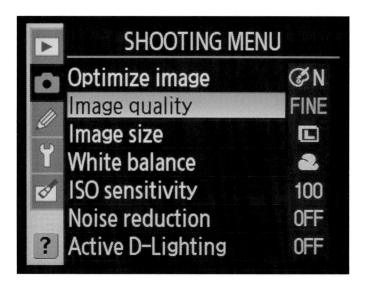

Fine is the highest JPEG quality setting. The last option will record a RAW file and Basic JPEG file for each photo taken. These choices can also be made through the Quick Settings Display. For more information on quality settings and JPEG and RAW files see Part 1: The Camera.

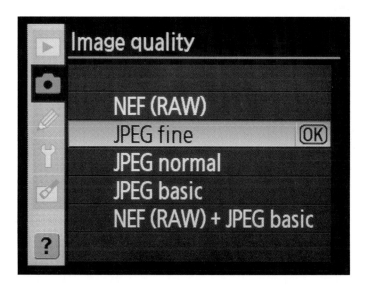

IMAGE SIZE

The Image Size menu is available if you choose one of the JPEG options for Image Quality. If you choose the RAW file format Image Size will be grayed out because there is just one size for the RAW file.

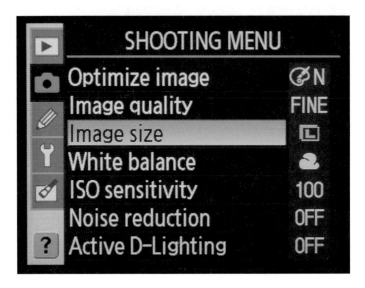

The options show you the pixel dimensions of each size and the corresponding number of megapixels (MP). Choosing the largest quality size will give you the most options for future use of our photos. These choices can also be made through the Quick Settings Display. For more information on image size see Part 1: The Camera.

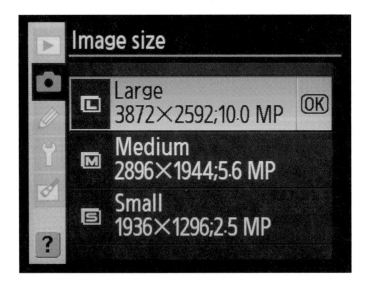

WHITE BALANCE

White balance helps to avoid unnatural color casts when photographing under various light sources.

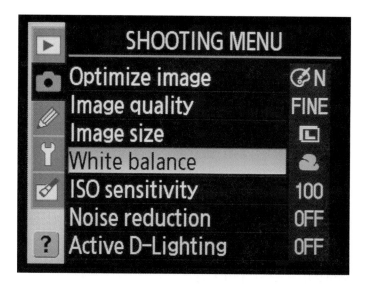

Auto white balance is a good option that doesn't require you to change the white balance every time you're under a different light source. White balance can also be set through the Quick Settings Display. For more information about the white balance settings see Part 1: The Camera.

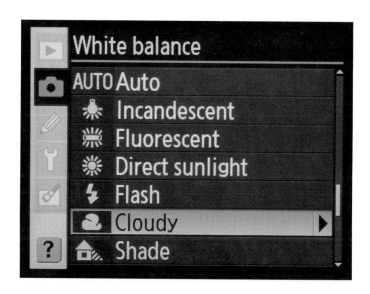

One white balance feature only available through the menu is fine-tuning the individual settings. If the white balance is doing a pretty good job, but you'd like to slightly adjust how warm or cool the photos are, you can try fine-tuning. It is available in the form of a color grid for auto, incandescent, direct sunlight, flash, cloudy, and shade. Select the white balance you want to fine-tune and press the multi selector right to bring up the grid. Then use the multi selector to move the black dot around. For more warmth try the yellow or red quadrants. To shift cooler try the green or blue quadrants. Press OK when you're done. Press ⬤ to cancel.

Fluorescent fine-tuning doesn't have a color grid, but it lets you choose different types of fluorescent light. If you're not sure which one is right, pick one, take a picture, and see how the image looks. Repeat the process until you find the one that gives you the best results.

If neither Auto white balance nor any of the standard choices are producing good results, you may want to try setting a custom white balance. It's the last choice in the white balance menu: Preset Manual.

To create a custom white balance you can either take a measurement yourself or copy the white balance from a photo on your memory card.

When choosing the Measure option you'll be asked if you want to erase existing information. This is because you can only have one custom white balance saved at a time. If you haven't created one before then it doesn't matter since there's really no information. Choose Yes to continue.

The next message instructs you how to take the picture to measure the white balance.

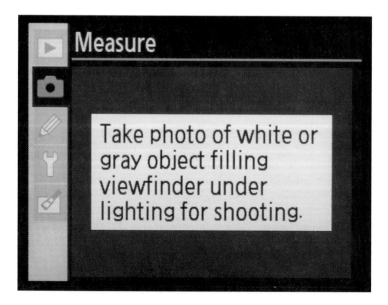

Place a white or neutral gray object (a piece of paper works great) under the light where you want to photograph. Get close or zoom in on the object so that it completely fills the viewfinder. The object doesn't have to be in focus. Take a picture. If the camera was able to measure the light the message "Data acquired" will appear at the top of the monitor. If there was an error you'll get the following message: "Unable to measure preset white balance. Please try again." If this happens go back to the white balance menu and go through the steps again.

To use the white balance from an existing photo, select the thumbnail of the image. This feature is useful if the camera got the white balance just right for a certain picture, but for some reason you can't get it to produce the same result again.

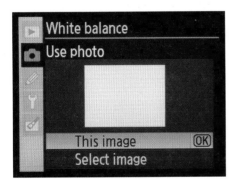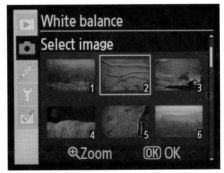

Once your custom white balance is set by measuring or selecting a photo, it's listed as PRE. The camera will use this custom setting until you change to another white balance setting.

ISO SENSITIVITY

The ISO Sensitivity refers to how sensitive the sensor is to light. At higher ISO numbers the camera needs less light to make a good exposure. This can allow you to use faster shutter speeds or smaller apertures while still achieving a proper exposure. Be aware that using high ISOs can also produce noise, which causes a grainy appearance that results in a loss of fine detail. ISO Sensitivity can also be set through the Quick Settings Display. For more information about the ISO sensitivity see Part 1: The Camera.

Auto is grayed out because it has to be turned on through the "ISO auto" setting in the Custom Setting Menu.

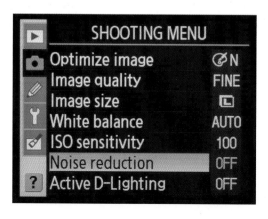

NOISE REDUCTION

Noise can have negative effects on your images, but using noise reduction can help. Noise can produce a mottled appearance in areas with a solid color (such as a blue sky), soften fine details, and cause random pixels (appearing as small pinpoints in your photo) to be brightly colored. Noise is caused by taking pictures at high ISOs and by using very long exposures (multiple seconds).

I recommend turning on noise reduction because it will reduce the amount of noise in two situations:

1. When you use an ISO above 400. In this case if you use the continuous shooting mode (with noise reduction on) you won't be able to take pictures as quickly. Keep this in mind if you're trying to capture action shots, as you might want to turn noise reduction off.

2. When the shutter speed is eight seconds or slower. After taking a picture "Job nr" will blink at the bottom of the viewfinder while the camera is processing the image to reduce noise. You can't take another picture until this message disappears and the camera finishes recording the image. "Job nr" will blink for the same length of time as your exposure. For example, if your shutter speed was ten seconds, then "Job nr" will blink for ten seconds. Don't turn the camera off while "Job nr" is blinking or the noise reduction won't be applied.

ACTIVE D-LIGHTING

Active D-Lighting is an adjustment the camera applies to retain more detail in the highlight and shadow areas of your pictures. It can be useful in high contrast situations where part of the scene is very bright and part is dark. Active D-Lighting can also be set using the 🔘 button or through the Quick Settings Display. For more information about Active D-Lighting see Part 1: The Camera.

CUSTOM SETTING MENU

The Custom Setting Menu offers options for specializing camera functions and features to your needs/preferences. You won't need to use this menu very much if you don't want to. Some settings you can set once and won't need to change them. Other settings that you'll use regularly can be accessed more quickly through the Quick Display Settings.

RESET

If you reset the custom settings menu all the settings are returned to their defaults (what they were when you got the camera).

BEEP

The D60 automatically beeps whenever the autofocus locks onto a subject or when the self-timer or remote control is used. If you don't like the beep you can turn it off.

FOCUS MODE

In focus mode you can choose one of the three autofocus modes (auto-servo, single-servo, continuous servo) or manual focus. You can also change the focus mode through the Quick Settings Display. For more information about focus modes see Part 1: The Camera.

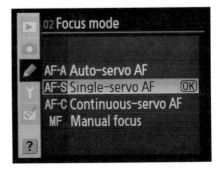

AF-AREA MODE

The options for autofocus area mode control how the autofocus system locks onto a subject. Closest Subject focuses on the nearest subject in front of the camera. Dynamic Area is good for tracking moving subjects. With Single Point the camera stays focused on the same area in the viewfinder. You can also change the AF-area mode through the Quick Settings Display. For more information about AF-area modes see Part 1: The Camera.

 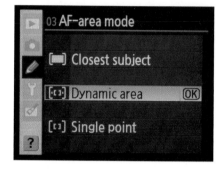

RELEASE MODE

Release mode gives you options for taking pictures one at a time, continuously, on a timer, or using a remote. Using Custom Setting #16 you can change the length of the self-timer, but we'll get to that option later on. You can also change the release mode through the Quick Settings Display. For more information about release modes see Part 1: The Camera.

 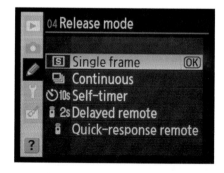

METERING

The metering options offer different ways for the camera to measure the light on your subject or scene. The metering options are matrix, center-weighted, and spot. You can also change the metering through the Quick Settings Display. For more information about metering see Part 1: The Camera.

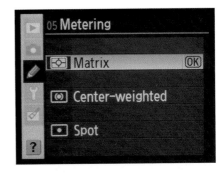

NO MEMORY CARD?

The No Memory Card option lets you choose what the camera will do if there is no memory card in the camera and you try to take a picture.

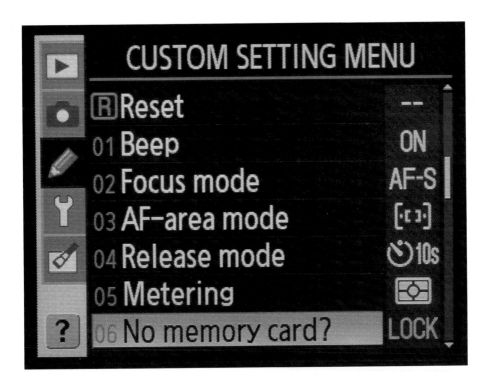

Release locked means you can't take a picture when there is no memory card.

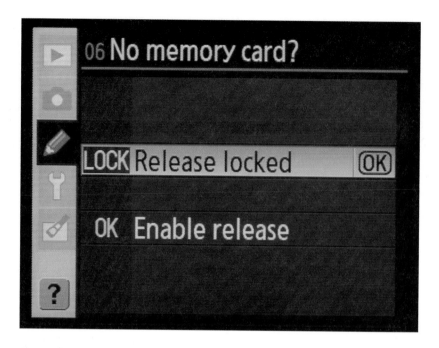

If you turn on the camera and there is no memory card inserted (and you've chosen "Release locked") you'll see a warning message at the top of the monitor:

If you try and take a picture nothing will happen.

If you choose "Enable release" the camera will give you no warning that there is no memory card. It will let you meter and change setting just as if everything is normal. You can even take a picture. The picture will appear on the monitor, but it will have the word "Demo" in the top left. You can even go through all the screens of information (histogram, highlight warning, etc.) for the photo. This photo is in the camera's temporary storage, it's not really saved anywhere. The D60 will remember up to seven of these pseudo-pictures, as long as you don't let the monitor turn itself off.

Keeping the D60 set to Release Locked is a good safety precaution to avoid accidentally taking pictures when there's no memory card.

IMAGE REVIEW

Image Review controls whether your picture appears on the monitor right after you take it.

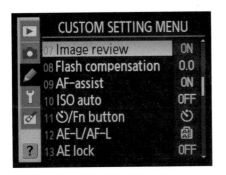

On: Photo appears on the monitor after you take a picture.

Off: No photo appears, the monitor shows the shooting info display.

Image review makes it easy to see what you just shot. If you don't want to look at every photo right after you take it, you may find image review annoying.

FLASH COMPENSATION

Using flash compensation you can adjust the power of the flash. You can increase the power of the flash a little (up to +1), but you get a great range of control by decreasing the flash power (down to −3). You can also change the flash compensation through the Quick Settings Display. For more information about flash compensation see Part 1: The Camera.

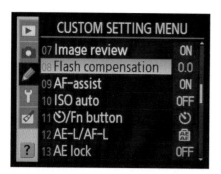

AF-ASSIST

Autofocus assist uses the lamp on the front of the D60. It looks like a little headlight near the shutter release button. If you have AF-Assist set to "On" the lamp will light up when the camera senses dim lighting to literally throw some light on your subject. By shining a mini-spotlight on your subject the camera creates more contrast, making it easier for the autofocus to lock on to your subject.

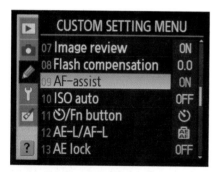
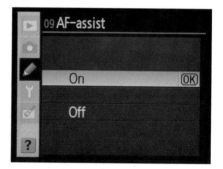

TIP

The AF-Assist lamp will work on subjects that are about two to nine feet away. It won't light up when using continuous-servo autofocus (AF-C) or manual focus (MF).

ISO AUTO

ISO Auto lets the camera change the ISO, if the ISO you have picked won't produce a correct exposure. The custom setting menu is the only place you can turn on/off ISO Auto.

ISO Auto lets you set a maximum ISO and a minimum shutter speed. You can use these settings to avoid a very high ISO and to make sure the camera doesn't pick a shutter speed that is too slow. For more information about ISO Auto see Part 1: The Camera.

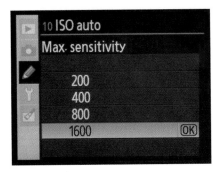 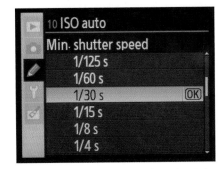

FN BUTTON

Fn stands for function. Think of the function button as a shortcut button. The function button is located on the left side of the D60 near the flash button and the silver D60 label.

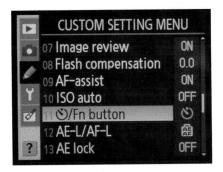

You can access one of the following functions with this button:

- Self-timer: Press the Fn button once to switch to self-timer mode. Press the button again to go back to regular release mode (single, continuous).
- Release mode (single, continuous, timers, remote): Press and hold the Fn button then turn the command dial to change the release mode.
- Image quality/size (JPEG, RAW): Press and hold the Fn button then turn the command dial to change the image quality/size. Using the Fn button you can't pick the quality and size individually, but if you keep turning the command dial it will cycle through all the possible combinations.

- ISO sensitivity: Press and hold the Fn button then turn the command dial to change the ISO.

- White balance: Press and hold the Fn button then turn the command dial to change the white balance.

Think about which of these functions you'll use the most and choose that one for the function button. Using the function button and the command dial to change a setting is quicker than having to go into a menu or even the Quick Settings Display.

AE-L/AF-L

This menu item sets the function for the 🔘 button. The default function locks the exposure (meter reading) and the focus when you press and hold it.

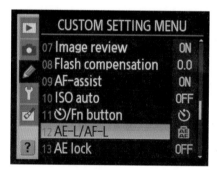 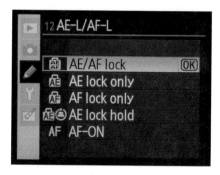

Here are all the options you can choose from:

- AE/AF Lock: Press and hold to lock the exposure and focus.
- AE Lock Only: Press and hold to just lock the exposure.
- AF Lock Only: Press and hold to only lock the focus.
- AE Lock Hold: Press and release to lock the exposure, press again to remove the exposure lock. It's convenient because you don't have to hold down the button. The exposure lock will go away if the meter in the viewfinder goes dark or the camera is turned off.
- AF-On: If this option is selected then you have to press the AE-L/AF-L button to use autofocus. The shutter release button will no longer activate autofocus.

AE LOCK

AE Lock controls whether the shutter release button locks the exposure when it's pressed halfway down.

Off: Shutter release button does not lock the exposure (default setting, and good for most types of photographs).

On: The exposure is locked when the shutter release button is pressed halfway down.

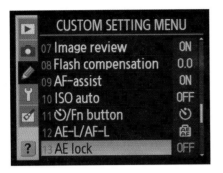
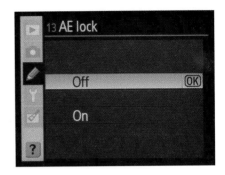

BUILT-IN FLASH

Built-in Flash lets you choose to operate the flash in auto (TTL) or manual mode.

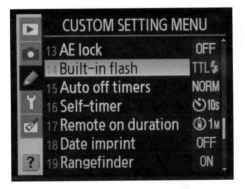

TTL is the standard flash mode and it works great for most photography. The D60 adjusts the power of the flash to the subject and lighting. You can use the Flash Compensation to adjust the power of the flash.

When using manual flash mode you have to choose the power output of the flash. The output options are listed as fractions. Full power is the most output, next is half full power, then one-quarter of full power, and so on. Unless you need to be really precise or the TTL just isn't working as expected, manual flash mode isn't necessary.

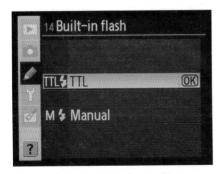
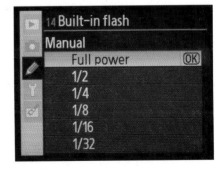

TIP

If you attach an external flash unit, such as Nikon's SB-400 Speedlight, the name of this setting changes to "Optional flash unit." The options here would then control the mode and output of the SB-400.

AUTO OFF TIMERS

Auto Off Timers control how long information is displayed on the monitor or in the viewfinder. If you're not pressing buttons for a certain period of time they'll go dark.

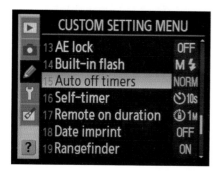

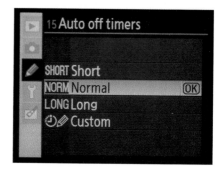

You can choose from general descriptions of length for the timers: short, normal, and long. Yet even within short, normal, and long the length of the timer varies depending on the monitor vs. the viewfinder. Here's the breakdown:

Short	Image playback and menus: monitor goes off after 8 seconds.
	Photos are shown for 4 seconds after taking the picture.
	Exposure meter (shooting info display on monitor and in viewfinder): turns off after 4 seconds.
Normal	Image playback and menus: monitor goes off after 12 seconds.
	Photos are shown for 4 seconds after taking the picture.
	Exposure meter (shooting info display/viewfinder): turns off after 8 seconds.
Long	Image playback and menus: monitor goes off after 20 seconds.
	Photos are shown for 20 seconds after taking the picture.
	Exposure meter (shooting info display/viewfinder): turns off after 1 minute.

You can also customize the timers by choosing the length of each one individually.

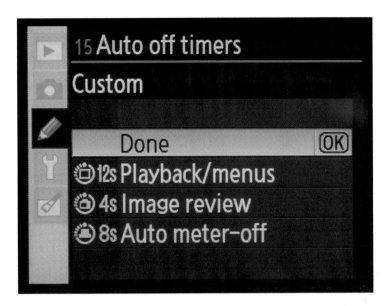

SELF-TIMER

With the self-timer you can set the length of the delay before the picture is taken. To actually select the self-timer to use it, you need to go to Release Mode (use the Quick Settings Display or go to Custom Setting #4).

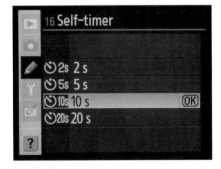

REMOTE ON DURATION

Remote on Duration is related to using the optional remote control to take a picture. Once you select Delayed Remote or Quick Response Remote, the "remote on duration" is the amount of time the camera

will wait for you to use the remote. If you don't use the remote in that period of time the D60 will switch back to your previous release mode (single or continuous). To choose the Release Mode use the Quick Settings Display or go to Custom Setting #4.

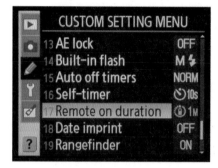 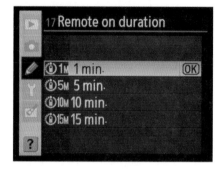

DATE IMPRINT

Date Imprint will "stamp" the date on every photo you take. It becomes a permanent part of the photo. It's placed in the bottom right corner of the image. If you have the date/time imprinted you can't choose to remove it later. Make sure you want to see it on every photo before turning this option on. Date imprints won't appear on RAW photos.

Date Counter will imprint a number count as to how many days it is before or after a date you specify. For instance if you enter 6/1/08, then you take a picture on 4/1/08, the D60 will imprint "60" because that's how many days it is until 6/1/08.

RANGEFINDER

The Rangefinder is a useful feature when you're manually focusing. With the D60 set to manual focus mode, look through the viewfinder and you'll see a "0" at the bottom in the center. To the left or right of the zero will be a small arrow. The arrow gives you an indication of how to turn the focusing ring on your lens to bring your subject into focus. You turn the focusing ring in the opposite direction the arrow is pointing. If the arrow is on the left turn the ring to the right. You want to turn the ring until there is neither an arrow on the left or right, but just two little lines under the zero. This means your subject is in focus.

> **TIP**
>
> Be sure to have your subject in the active focusing bracket for the Rangefinder to produce good results. Tap the shutter release button while looking through the viewfinder. Whichever bracket flashes red is the active one. Press the multi selector right or left to change the active focus bracket.

SETUP MENU

There are only a few settings in the Setup Menu that you'll likely need to come back to after you set them initially.

CSM/SETUP MENU

This is the menu we went to at the beginning of the section to choose "Full" so that we would have every menu option available. The "Simple" option hides some of the choices in the Custom and Setup Menus. Here are the settings the Simple menu hides:

Custom Menu: Image review, Flash compensation, AF-assist, ISO auto, Fn button, AE-L/AF-L, AE lock, Built-in flash, Auto off timers, Self-timer, Remote on duration, Date imprint, and Rangefinder.

Setup Menu: Folders, File no. sequence, Clean image sensor, Mirror lock-up, Firmware version, Dust off ref photo, and Auto image rotation.

By choosing the Simple menu you'll have less choices to look through when going to the different menus. After you get an idea of which settings will work best for you and which ones you'll be using, take another look at the settings hidden by the Simple menu. If you think you won't miss the hidden settings, using the Simple menu can cut down on the menu "clutter."

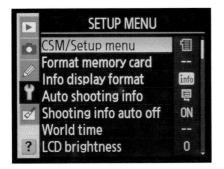

If the Simple menus are too basic and the Full menus too much, you can also customize your menus by choosing "My menu." In the My Menu screen you view the settings for each menu separately and choose which ones you want to include. If you uncheck the box next to a setting, that setting won't appear in your menus.

For example, here are the settings available in the Playback Menu. By unchecking boxes you're able to choose just what you want in your menus. You can always come back later and adjust your choices.

FORMAT MEMORY CARD

After you have downloaded your photos to your computer and backed them up (see Part 2), you can erase your memory card to make way for new photos. This is called formatting your card. After choosing "Format memory card" a warning message will appear to make sure you really want to delete all your photos. It's better to erase your card by formatting it in the camera instead of using your computer to do it.

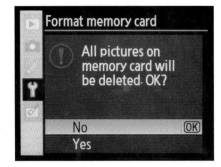

INFO DISPLAY FORMAT

The D60 gives you a variety of options for how the shooting info is displayed on the monitor.

You can choose a different look for your different exposure modes. You can have one look for the P, S, A, and M modes and another for the Digital Vari-Program modes (auto, portrait, landscape, etc). This might not be all bad. It could help you be aware of which group of exposure modes you're using. The options are the same for either group. For the examples below I've chosen to adjust for the Digital Vari-Program modes.

The overall appearance options are Classic, Graphic, and Wallpaper. For Classic and Graphic you then choose a background color.

Graphic Display: This is the default display. It has the aperture graphic on the left to show you the size of the aperture as you change f-stops.

Classic Display: Gets rid of the aperture graphic and makes the numbers larger for your basic shooting information (aperture, shutter speed, number of pictures remaining).

Wallpaper: For wallpaper you pick an image from your memory card and it's used as a backdrop for your shooting information. Choose "Select wallpaper" from the main Info Display Format screen, then pick your photo.

Once you've selected your wallpaper go back to Digital Vari-Program or P, S, A, or M. Choose wallpaper as your display option. Next, pick whether you want a dark or light font for your numbers/info. Think what would be most easily seen on top of the photo you've chosen.

 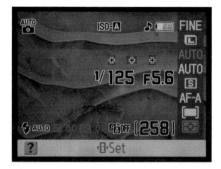

The layout of the info is similar to the Graphic display, but without the aperture graphic.

AUTO SHOOTING INFO

You can have the shooting info displayed when you press the shutter release button halfway then release it.

On: Shooting info will be displayed (press shutter release halfway and release it).

Off: Shooting info won't be displayed. If the monitor has gone dark, pressing the shutter release won't bring up any info. You can still show the shooting info by pressing .

You can choose separate settings for the Digital Vari-Program modes and the P, S, A, and M modes.

SHOOTING INFO AUTO OFF

I find this is a very useful feature. Right before you take a picture you're often using the shooting info display. When you go to look through the viewfinder you don't want that bright display glaring under your eye. Nikon came up with a great solution. There are two small sensors right above the monitor. When they sense something close to the monitor the D60 turns the monitor off.

To take advantage of this feature set Shooting Info Auto Off to "On." You can even try it out using your hand. Put your hand close to the monitor and it goes dark. Pull your hand away and the monitor turns back on.

WORLD TIME

You set this info when you first turned on the D60 and did the set-up steps. If you need to change your time zone or adjust the date format you can do that here.

LCD BRIGHTNESS

LCD brightness adjusts the brightness of the monitor. If it's particularly bright outside you could try increasing the brightness if you're having trouble seeing the monitor clearly.

The other option under LCD Brightness is auto dim, which is a power saving feature. The D60 uses the monitor for everything from displaying shooting info to accessing menus to reviewing images. Monitor usage can drain the battery. If you turn Auto Dim "On" the shooting info display will gradually dim. It won't go dark, just from bright to a little less bright. You may not even notice it's happening if you're not watching it. You can bring the display back to full brightness by pressing the shutter release halfway.

VIDEO MODE

When connecting the D60 to a television or other video device select the setting appropriate for the device.

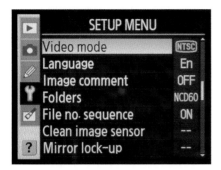 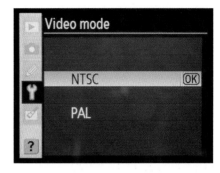

LANGUAGE

Language was selected when you initially set up the camera. However you can always change it if you would like the menus and messages displayed in a different language.

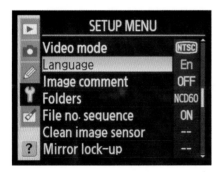 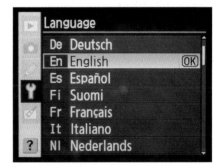

IMAGE COMMENT

Image Comment allows you to attach a text comment to your images. This comment is stored as part of the image along with shooting data such as aperture and shutter speed.

When you go to input a comment you're given a "keyboard" to spell out your comment (up to 36 characters long). Press OK to enter letters. Turn the command dial to move the cursor for inserting or deleting a letter. Press 🔘 to delete a highlighted letter. Press 🔍 when you finish your comment and it will be saved.

To have the comment attached to future pictures you take (it can't be attached to photos already taken) move down to "Attach comment" and press the multi selector to the right to check the box. You can always go back and uncheck the box (comment is still saved) if you no longer want it attached to photos.

In the playback mode one of the detail screens has "COMMENT" listed at the bottom (no comment attached for this photo).

FOLDERS

By default the D60 has a single folder in which all photos are stored. You can use the Folders menu item to create new folders, rename folders, and delete folders (only if they're empty). Folders can be used to help organize images as you take them; for instance, if you're traveling you could create folders for each of your major destinations. Then select the appropriate folder for your location and all the photos from that place will be in their own folder.

If you have more than one folder you can select which one you want your photos saved in.

You can choose the name of new folders you create.

Existing folders can be renamed (except for the original folder the D60 creates).

FILE NO. SEQUENCE

File no. sequence determines how the D60 names your images.

When "On" is selected the file number for each image will be one higher than the previous up to 9999, then it resets back to 0001; for example, the files will count up 0001, 0002, 0003, 0004, 0005, and so on. This count will continue even if a new memory card is used or the memory card is formatted.

If you select "Off" the file number will still begin counting up as described above. However, when a new or formatted memory card is used the file numbering returns to 0001.

Reset would be used if you wanted to force the camera to go back to 0001 and start counting up again.

I suggest using the "On" setting because it ensures you won't accidentally end up with duplicate file names on your computer. If you have two photos with the same file number there is the possibility that one can get deleted.

CLEAN IMAGE SENSOR

The D60 has the extremely useful ability to clean the sensor itself. With an SLR camera dust and dirt will eventually get inside the camera and find their way to the sensor. Having a self-cleaning sensor can help avoid unwanted dust spots in your pictures.

 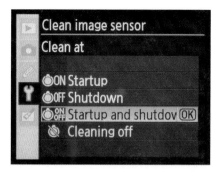

The "Clean now" choice lets you clean the sensor whenever you want.

The "Clean at" option allows you to tell the camera when to automatically clean the sensor. You can have it clean the sensor when the camera is turned on, when it's turned off, or both. You also have the option to turn off the automatic cleaning. If you have the D60 clean the sensor at startup and/or shutdown you will see a brief message at these times telling you the sensor is being cleaned. I don't think it hurts to have it clean the sensor at startup and shutdown, although if you just wanted to pick one I'd go with cleaning at Startup. Then the sensor's cleaned right before you want to start taking pictures.

MIRROR LOCK-UP

Mirror lock-up is used when you want to clean the sensor yourself. See Part 1: Batteries, Memory Cards and Maintenance for more information on sensor cleaning.

After you select "On" press the shutter release button all the way down, as though you were taking a picture. This will expose the sensor for cleaning. When you've finished inspecting or cleaning the sensor turn the camera off. When you turn the camera on again you'll be back to regular camera operations.

FIRMWARE VERSION

The firmware screen tells you what version of firmware the camera is using. Unless Nikon releases an update for the D60 firmware, both A and B will stay at 1.00. No need to do anything here.

TIP

The battery icon in the shooting info display must have more than one section remaining (a full battery icon has three sections). If the battery is too low on power the mirror lock-up setting will be grayed out and you won't be able to select it.

DUST OFF REF PHOTO

Dust Off Ref Photo is related to dust and sensor cleaning. You can use this option to take a photo of a white object with no detail. The data captured in the photo can be used by Nikon's Capture NX software to identify and remove dust from your images. This data can only be used by Capture NX.

AUTO IMAGE ROTATION

If you turn "On" Auto Image Rotation the D60 will sense the orientation of the camera (horizontal or vertical) and record this information with the image. The benefit comes when you look at the photos on your computer. The vertical pictures will be correctly oriented instead of you having to turn your head to see the photo or spend time rotating all the vertical pictures yourself. I would definitely have this setting turned on.

TIP

When you're in Playback mode you can jump to the retouch options by pressing OK. A retouch menu pops up and you have access to all of the options found in the real menu, except image overlay. You also have one option that isn't available in the regular Retouch Menu: Before and After comparison. Find a retouched photo in Playback mode, press OK, and go all the way to the bottom of the list. When you choose Before and After you'll see a side-by-side comparison of the original photo and the retouched one.

RETOUCH MENU

The Retouch Menu offers a set of options for adjusting your images while they're still in the camera. Pretty convenient! After selecting one of the retouch items you choose the photo from your memory card that you want to adjust. After the retouching is finished, the D60 will create an adjusted copy of your photo. You aren't actually changing the original photo, so you can always go back to it if you don't like how the retouched image turned out. When you play back your images the retouched photos will have an icon in the top left to tell you it's a retouched photo.

QUICK RETOUCH

Quick Retouch increases the contrast and saturation and brings out details in areas of shadow.

You can choose from a low, normal, or high amount of retouching. Your original photo is shown on the left so you can compare it to how the retouched version will look.

Press OK to save the retouched version. You're then switched to Playback Mode to view the retouched image. This will happen when you create a retouched photo with any of the tools.

D-LIGHTING

D-Lighting will brighten the shadows in your images.

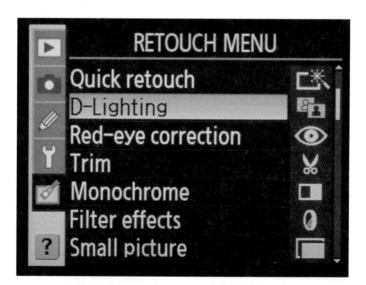

Select your image then choose from a low, normal, or high amount of D-Lighting. Use your original image on the left as a measure of how much D-Lighting will change your photo.

RED-EYE CORRECTION

The D60 will attempt to detect red-eye in photos where flash was used. This tool won't let you select an image if the flash wasn't used. If the camera can't detect red-eye it won't create a corrected copy. The camera will show you a preview before saving a copy. To check the quality of the results you can use the 🔘 and 🔍 buttons to zoom in/out then use the multi selector to move around the image.

If no flash was used there will be an X on the photo to tell you that you can't select it.

TRIM

Trim gives you the ability to create cropped versions of your photos.

After selecting your photo, press the 🔍 and 🔍 buttons to increase or decrease the size of the crop. You can use the multi selector to move the crop box around. While you can carefully position the crop box, you can't fine-tune the size of the crop any more than what the zoom in/out buttons allow.

MONOCHROME

The Monochrome option gives you three settings to choose from: black and white, sepia, or cyanotype. A monochrome image is either black and white or only made up of varying tones of one color. The sepia and cyanotype options let you adjust the saturation. Experiment with different photos to see what works for the different monochrome options.

Sepia tone images have a reddish-brown appearance.

Cyanotype images are blue-tinted.

FILTER EFFECTS

Filter Effects offer a variety of filters that affect the colors in a photo. Consider the colors and subject of your photo when deciding which filters to try.

The Skylight Filter adds a little warmth to photos by removing blue.

The Warm Filter adds more warmth than the Skylight Filter. The Red Intensifier creates stronger red tones.

The Green Intensifier increases green tones and the Blue Intensifier strengthens the blues in an image.

With the Cross Screen Filter bright areas become the center of a star pattern with lines radiating outward. You can choose how many star points there are as well as the length of the points.

You can use the Color Balance Filter to add an overall color cast to a photo. Use the multi selector to move the black dot to the area of color that you'd like to add to the image.

SMALL PICTURE

Are you shooting at the high quality JPEG setting, but have a photo you'd like to e-mail to a friend? No problem, just use the Small Picture Tool to create a smaller version of your photo. Then, as soon as you download your photos, you can attach that image to an e-mail.

After choosing your picture, select the size for your small picture.

IMAGE OVERLAY

Image Overlay is an option for blending or combining two RAW photos. JPEGs can't be used for overlays. Press OK to go to the thumbnail view to pick a RAW file. After selecting your first image, repeat the process for choosing a second image. After you have photos for Image 1 and Image 2, you can use the multi selector to adjust the numbers below the thumbnails. These numbers adjust the density of each photo.

NEF (RAW) PROCESSING

The RAW Processing is used to create an adjusted JPEG copy of your RAW photo.

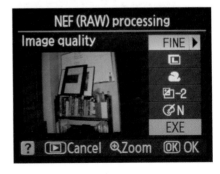

After selecting the photo to adjust you have a number of options. Let's work from the top down. First, choose the JPEG quality and then the size. Next you can change the white balance. After white balance you can adjust the image brightness by changing the exposure compensation. The final choice (above EXE) is to optimize the image with options such as neutral, softer, vivid, and black and white. When you're done with all your adjustments go down to EXE and press OK to save the JPEG copy.

STOP-MOTION MOVIE

Stop-Motion Movie lets you combine a number of photos on your memory card into a movie. Your first set of options are the frame size and frame rate for the movie.

Next choose which photo you want to be at the start of the movie and which one will be at the end. The movie will now include all the photos between the starting and ending images.

You can now save your movie. If you'd like to remove select images from the movie, or change the starting or ending slides, select Edit.

To play your stop-motion movie go to the Stop-Motion Movie option in the Playback Menu.

Batteries, Memory Cards and Maintenance

MEMORY CARDS

The D60 uses Secure Digital (SD) memory cards. SD cards come in two varieties: SD and SDHC. The D60 can use both types of cards. SDHC are higher capacity cards than the regular SD cards. SDHC cards start at 4 GB capacities and currently go up to 16 GB.

On SD memory cards there is a slider on the left edge which has "Lock" written next to it. If the slider is in the up position the card is in "write" mode and you can save pictures to it. If you move the slider down, the card will be locked. If a locked card is inserted into the D60 you'll see the following message when you turn the camera on: "Memory card is locked. Slide to "write" position."

Whenever you get a new memory card you should format it in the D60 before you take pictures with it. To format the memory card to the Menus, choose the Setup Menu and then select Format Memory Card. You can also format the card when you want to erase all the photos on it.

TIP

Format the memory card in the camera instead of erasing the photos using your computer.

TIP

Always make sure the camera is off before you remove the memory card.

TIP

Don't turn the camera off if the memory card access lamp is lit up. This means the camera is accessing the memory card and turning it off could interrupt this process, possibly damaging the photos on your card.

On the back of the memory card are the electronic contacts. Take care not to touch these contacts or get them dirty.

To download photos to your computer use either a card reader or connect the D60 directly to your computer with the provided USB cable. When looking for a card reader make sure it can read SDHC memory cards. Often card readers will have numerous slots for various types of cards, or you may be able to find one that is just for SDHC/SD cards.

BATTERIES

- The D60 uses a rechargeable battery. If the battery is completely depleted it will take about 90 minutes to recharge.

- The D60 battery fits pretty snugly in its plastic case so it isn't very easy to pull it out. To get the battery out push the battery up through the hole in the bottom of the case.

- It's a good idea to have an extra battery just in case your main battery runs out while you're out photographing. That's especially important if you're traveling. It's no fun to miss pictures because your battery died.

- If you're photographing in cold weather the battery will not last as long. Bring along a spare and keep it inside your jacket to keep it warm.

- Keep any extra batteries in their protective plastic cases to protect the battery contacts.

To remove the battery open the battery compartment door and turn the camera right side up. The battery will drop down slightly, coming a little ways out of the camera body. Give the battery a good pull and it'll come out of the camera. The good new is, if you accidentally open the battery door, the battery won't fall out!

MAINTENANCE

TIP

When a lens isn't on the camera keep the rear cap and lens cap attached. This will protect the glass and electronic contacts from getting dirty or damaged.

CAMERA CLEANING

The following accessories are helpful for cleaning the outside of your camera and lenses:

- Brush: Used to gently brush off dust and dirt particles.

- Blower: Sometimes called a rocket blower, it's used to blow out puffs of air to clean off particles of dust and dirt.
- Microfiber cleaning cloth: Used for wiping smudges and fingerprints off the front of your lens and the monitor.

If there is dust, dirt, or other particles on the front of your lens brush or blow them off first. Then use a cleaning cloth for smudges on the glass. You don't want to use the cloth first because if you rub the particles around on the front of your lens they may scratch the glass.

If you're photographing at the beach, or somewhere else near saltwater, wipe down your gear at the end of the day. Dampen a cloth with regular water and wipe off all camera and lens surfaces. The salt spray can be damaging to your equipment if it's not cleaned off.

KEEPING YOUR SENSOR CLEAN

One major difference between compact digital cameras and digital SLRs, like the D60, is that you can attach different lenses to the camera. However, taking lenses on and off the camera exposes the sensor to dust and dirt. If tiny pieces of dust and dirt land on the sensor, they will appear as little black specs on every picture you take.

One of the great features of the D60 is the self-cleaning sensor. To see the sensor cleaning options go to the Menus, choose the Setup Menu, then go down to Clean Image Sensor. There is also information about this setting in Part 1: Menus. Even though the sensor will clean itself, it's still a good idea to do what you can to help keep it clean.

- Turn the camera off before changing lenses (when the camera is on the sensor has a static charge which can attract dust and dirt).
- Keep the camera pointing down when changing lenses (this avoids the potential for any particles falling into the camera and making their way onto the sensor).
- Minimize the amount of time a lens is not on the camera (if you are switching lenses, have the next lens ready to put on the camera).
- Don't remove the lens if you don't need to (when you're done photographing you don't have to remove the lens to store the camera)
- Don't worry! The sensor won't start attracting dust the second it's exposed to outside air, but following these suggestions and using the self-cleaning sensor option will go a long way toward keeping your sensor clean.

TIP

How to check for dust on your sensor:

Go outside on a day with a blue sky. Set your exposure mode to Aperture Priority and choose f/22 for your aperture. Point the camera at the sky (it doesn't matter if it's in focus) and take a picture. Review the photo on the monitor by zooming in or look at it on your computer enlarged to 100%. If you see any dark specs there is dust on the sensor.

SENSOR CLEANING

Of course nothing is perfect and even with the self-cleaning sensor you may eventually end up with dust on the sensor that can't automatically be removed. If this happens, you have a couple of options: send the camera to Nikon for sensor cleaning or find a local camera store that cleans sensors. Another option is to clean the sensor yourself. This may seem a little daunting at first, but if you take your time and are careful you'll get the hang of it after a few times.

There are two methods for sensor cleaning: wet and dry. Wet cleaning involves using a special swab, putting some cleaning solution on it, then wiping the swab across your sensor. Dry cleaning uses a brush which spins in order to pick up an electric charge. You then brush you sensor and the electric charge attracts dust particles to the brush and off your sensor. I find the dry cleaning method simpler and quicker. If I have a particularly stubborn piece of dust, then I would use the wet cleaning method. One company that makes products for both types of cleaning is Visible Dust (www.visibledust.com).

I wouldn't worry too much about manual sensor cleaning. Take advantage of the sensor cleaning option in the D60 and see how good a job it does keeping dust off the sensor.

The Software

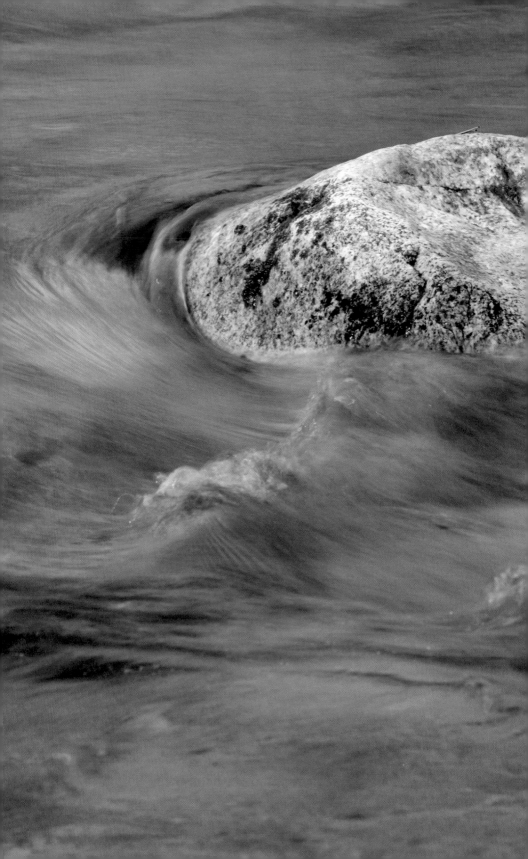

After you've taken a bunch of photos you'll want to get them on your computer. Nikon offers a few software programs that you can use to download, organize, and adjust your photos.

- Nikon Transfer (downloading photos)
- Nikon ViewNX (organizing and viewing your photos)
- Nikon Capture NX (adjusting JPEG and RAW files)

Nikon Transfer and Nikon ViewNX are on the Software Suite CD that came in the box with your D60. You can use the Software Suite CD to install these two programs. Nikon Capture NX must be purchased separately. Its regular price is $150, but you can likely find it for less through online merchants. You can also download a 30-day trial version of Capture NX from the Nikon Web site (www.nikonusa.com). In this section we'll look at what each of these programs has to offer and how to use them.

BUILDING AN IMAGE LIBRARY

Now that computers have become the storage devices for our photos it's important to have a system that will enable you to easily find them. Also critical is having a backup copy of your photos. No longer is there a shoebox or drawer with the negatives of our photos. If you just have one copy of your digital photos and something happens to them your pictures are permanently lost.

Before we look at downloading and viewing your pictures, let's think about where to put your pictures on your computer. I'd suggest having one folder named Photos or Pictures (your computer may already have created a folder with such a name). Then place all your photos inside that folder. When you need to find a photo you'll know right where to look because they'll all be in the same place. You may also want to further organize your photos by creating sub-folders within your main Pictures folder. What you name these sub-folders depends on how you want to group your photos. You could create folders for different subject matter such as family, vacation, landscapes, flowers, portraits, etc. Another option is to group by date, making sub-folders for each month, or perhaps you want to group your photos by where they were taken. Or you may decide it's easier to leave all the photos in one folder and not group them at all. How you organize them is up to you. What's important is to pick a system that works for you. Having all your photos in one main folder will make it much easier to find them.

One method for grouping your photos is by category.

To backup your photos there are a variety of storage devices available including CDs, DVDs, and external hard drives. I recommend using an external hard drive. They're compact, they're portable, and you can get lots of storage space for little money. You want the backup copy of your photos to be the same as what's on your computer. If you reorganize or delete the photos on your computer, it's easy to update an external hard drive as well, whereas with a CD or DVD you can't change the information once it's written. There are rewriteable CDs and DVDs, but they're not as reliable and I wouldn't recommend using them for long-term storage/backup. Also, if you use CDs/DVDs for backup don't put them in a closet and forget about them. CDs/DVDs are likely to be replaced by another storage media. Think back to when you used to use floppy disks. If you had a floppy disk now you'd have a hard time finding a computer to read it. When the next media format comes along you'll want to transfer your backed

up photos from the old medium to the new one. Whichever backup method you use, it will give you peace of mind knowing you have a duplicate set of your photos.

NIKON TRANSFER

Nikon Transfer offers a quick and easy way to transfer (download) photos from your memory card to your computer. But it does more than just download. Nikon Transfer can also rename your photos, automatically create a backup copy, and add IPTC info (more on that later). To get ready to download the first thing you do is connect your memory card to your computer. You can do this by using a card reader or by connecting the D60 directly to your computer. I'd suggest using a card reader because it's generally faster and doesn't use your camera's battery.

Here's how to set up using either method:

Downloading using a card reader

1. Turn your computer on.
2. Connect the card reader to your computer.
3. Remove the memory card from your D60.
4. Insert the memory card into the card reader's slot for SD cards.

Downloading using your camera

1. Turn your computer on.
2. Turn off the camera. Leave the memory card in the camera.

3. Connect the camera to the computer using the USB cable that came with the D60.

4. Turn on the camera.

After you have your memory card connected to the computer (via a card reader or the camera), open the Nikon Transfer program. When you first start the program you'll see a window that has three sections: Options, Thumbnails, and Transfer Queue. Next to each one is a dark circle with a triangle in the center. Click on any of the triangles to expand the information in that section.

QUICK DOWNLOAD INSTRUCTIONS

If you're not interested in Nikon Transfer's options and features and just want to download your photos here's what to do: just click the Start Transfer button in the bottom right of the Nikon Transfer window. That's it! All the photos on your memory card will be downloaded. I do suggest you check which folder is chosen as the primary destination (Options section, Primary Destination tab). This tells you where Transfer is putting your photos so you know where to find them! You can also change the destination folder.

OPTIONS SECTION

First click on the triangle next to Options. You're now presented with a row of tabs. Let's take a look at the choices for each tab.

Source

In the Source tab you choose where you're downloading the pictures from. Once the camera or card reader is connected a box will appear in this section identifying it. Click on the box to select it.

D60 connected. Card reader connected (your card
 reader may have a different name).

Embedded Info

The Embedded Info tab lets you add IPTC information to your photos when they are downloaded. IPTC information is stored within your image file. Remember when you play back photos and you can see shooting information about the pictures (aperture, shutter speed, ISO, white balance, etc.)? This shooting information is automatically stored as part of your image file. IPTC info works the same way, but you get to choose which information to add. Once you add it, the information becomes part of the image file, but you can change or delete it later.

TIP

If your card reader or D60 is not showing up, click on the "Search For" box and make sure there are check marks next to Cameras and Removable Disk. Removable Disk refers to the card reader. If a check mark is missing click on the appropriate word to add one.

Using this feature of Nikon Transfer is a quick way to add the same information to all the photos you're downloading. However, it's not your only chance to add IPTC information. You can also add (or change) IPTC info using Nikon ViewNX and Capture NX.

Before we look at IPTC info, check the box next to "Embed ICC color profile during transfer."

Click on the Edit box to bring up the IPTC window.

The IPTC information is grouped by categories. You'll need to scroll down to see them all. It's important to remember that whatever information you add here will be added to all the photos you download at this time. So you want to make sure you're adding information that applies to every photo. Adding specific information to select photos is more easily done using ViewNX or Capture NX.

In the top left box Transfer comes loaded with preset groups of IPTC information. Click on each one and see how the displayed information changes. You can also add your own preset. By saving a set of your basic contact information, you can save time when downloading. Here's how:

1. Click the New button.

2. Enter a name for your set of info, such as Basic Info.

3. Press the Enter key.

4. Fill in the following information:

 a. Description section: Copyright: (c) 2008 {your name}

 b. Contact section: add as much info as you'd like

5. Click OK

Now you can choose your preset from the drop down menu. By choosing this preset your contact information will be automatically embedded in your photos. You won't have to type it in every time!

PRIMARY DESTINATION

In the Primary Destination tab you choose where your photos will be downloaded on your computer.

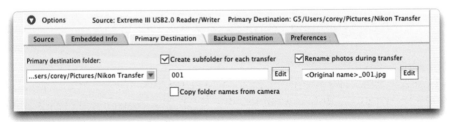

You also have a couple other options available. Whether you use them is a personal preference.

Create subfolder for each transfer

You can have a new folder created every time you download photos. This keeps the photos from each download in a separate folder instead of having all your photos together in one folder. Click on Edit to change how the subfolders are named.

Rename photos during transfer

Use this option to change the name of your photos. Click on Edit to see the choices available. Here's an example of how you could rename your photos: Hilz_080326_001.jpg, Hilz_080326_002.jpg, Hilz_080326_003.jpg

This renaming uses my last name (you could also use your initials), the date the photo was taken, and a string of numbers that counts up one for each photo. This method allows you to identify who took the photo and when it was taken just by looking at the file name. It will also keep your files in chronological order if you have many photos in the same folder.

Here's how to set up the file options to rename your files in this way:

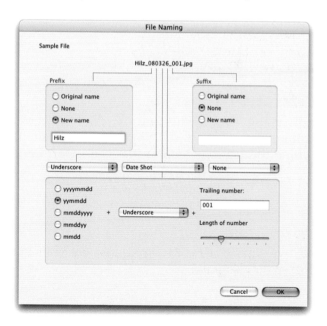

BACKUP DESTINATION

The Backup Destination tab lets you set up Transfer to automatically download your photos to a second location. Simply check the box next to "Backup photos," then choose the folder where you want

your photos backed up. Your photos should be backed up to a different hard drive than the one that has your original photos, because if something happens to your primary hard drive, then you'll still have a copy of your photos on your second hard drive.

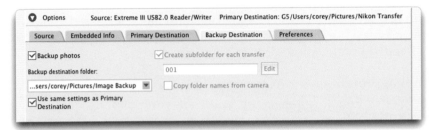

PREFERENCES

The Preferences tab includes a variety of options regarding how photos are downloaded and what Transfer does after your photos finish downloading.

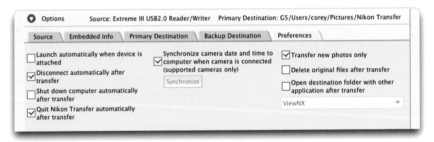

THUMBNAILS SECTION

Next let's look at the Thumbnails section. Click on the triangle icon next to "Thumbnails" to show the photos on your memory card. If you want to hide the Options section just click the triangle icon next to "Options."

You'll notice that each of the thumbnails has a checkbox under it. Every photo that is checked will be downloaded. If there are some photos you don't want to download click on the checkbox to remove the check.

The drop down menu next to "Group" offers a few options for sorting the photos on your memory card.

Grouping options

Shooting Date: Photos are grouped by the date they were taken. This option makes it easy to find photos that were taken on a particular day.

Extension: Sorts photos by the file extension such as JPG and NEF.

Folder: If your memory card has photos in multiple folders, the thumbnails are grouped by the folder they're in. Unless you've set up multiple folders on your D60, all your photos will be in one folder.

If you want to download all the photos from your memory card these sorting options aren't necessary. They can be a useful feature if you want to choose certain photos.

Above the thumbnails is a set of icons that you can use to automatically select, deselect, or delete certain photos.

#1: Selects all photos.

#2: Selects photos that have been marked for transfer in the camera.

#3: Selects photos that have been marked as protected in the camera. This means that when reviewing photos you pressed [AE-L/AF-L] to protect the photo from being deleted. Protected photos will have the key icon under the photo's file name.

This file is protected.

#4: Deselects all photos.

#5: Delete selected photos. It can be a little confusing as to what Transfer considers a "selected photo." If a photo has a check in the checkbox this does **not** mean it's selected for deletion. To select a photo you

must click on the thumbnail itself until the border around the photo turns light gray.

File DSC_0017.JPG is selected.

After clicking on one or more of the thumbnails, the trashcan icon darkens and you can click on it to delete the selected photos.

TRANSFER QUEUE SECTION

Click on the triangle next to Transfer Queue to show a list of all the photos that will be downloaded. The photos listed here are the same ones checked in the Thumbnails section. The queue tells you the names of the photos, the size of each image file, where it's coming from, and where it will be downloaded. If it says "(Multiple)" under Destination it's because you chose to have the photos backed up so they'll be downloaded to more than one place. If you change your mind and don't want to download all the photos listed, just click on the "X" at the far right to remove photos from the queue.

Now you're ready to download! Click the Start Transfer button in the bottom right of the window. The "Process" box in the bottom left will list where Transfer is in the download process.

NIKON VIEWNX

After you've used Nikon Transfer to download your photos, use Nikon ViewNX to look at your photos, organize them, and even attach them to an e-mail. Let's see what ViewNX has to offer.

Down the left side of the ViewNX window are three boxes: File Directory, Camera Settings, and XMP/IPTC Information. To show the information palettes for these sections click the "+" above the names in the boxes. The "+" turns to a "−"when the information for that section is open. You can only view the information for one section at a time. To close the displayed information, click on the "−."

Whenever any of the palettes are open three icons are always displayed at the top: left arrow, right arrow, and folder.

- Clicking the left and right arrows allows you to navigate to folders you have already viewed.

- If the arrow is light gray it means there are no more previously viewed folders in that direction.

- If the arrow is dark gray you can also click and hold on the arrow to bring up a list of folders you've viewed. This allows you to pick a previously viewed folder by name instead of having to click the arrows to get to it.

- Clicking the folder icon to the right of the arrows will take you up one level higher in the folder tree hierarchy.

FILE DIRECTORY

File Directory shows you a folder tree of the folders on your computer. Use the directory to locate the folder with your photos. Once you click on a folder the photos inside will be displayed in the browser to the right. If the folder does not contain any photos you'll see the message: "There is no file to display."

CAMERA SETTINGS

The Camera Settings palette has two halves. The top half is information about the settings on your camera when you took the photo. Click the triangle next to each category (File, Camera, Exposure, Flash, Image Settings, GPS) to view the information. The information in these categories can't be changed.

The bottom half is the Quick Adjustment section. If you took a picture in the RAW file format (NEF file extension) you can make selected adjustments to the photo here. The Exposure Compensation slider is used to make your photo lighter or darker. You can also set a different White Balance for the photo. Picture Control lets you change how the colors are rendered with settings such as Neutral, Vivid, and Monochrome. Once you're done making adjustments click Apply.

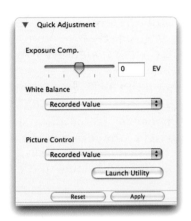

XMP/IPTC INFORMATION

The information in the XMP/IPTC palette probably looks familiar. It's the same set of groups/information that was available in Nikon Transfer. If you added any IPTC information to your photos when you downloaded them with Transfer you'll see it here.

Click the triangles to expand each group of information. After entering your information click Apply at the bottom. If you click a different photo without first clicking Apply the following message will pop up asking if you want to save the IPTC info you've added:

TIP

When you enter IPTC information it's added to whichever photos are selected. For instance, if you have three photo thumbnails highlighted, the IPTC info you enter will be added to all three photos. This feature makes it easy to add the same information to multiple photos.

If you click No, any IPTC information you just entered will be deleted. Unfortunately there's no way to "cancel" and continue entering information. If this message popped up because you accidentally clicked another photo it would be best to choose Yes to save the info, then go back and enter additional information.

To make more room for your photos close the File Directory, Camera Settings, or XMP/IPTC Information palettes if you don't need them.

TOOLBAR

There are a few ways you can have the toolbar displayed. To see the options available choose Customize Toolbar from the Window menu.

Depending on how much space you want the toolbar to take up you can have it displayed as icons, text, or both. Also you can select Use Small Size to further minimize it. The Customize option lets you remove items from the toolbar. If you decide you don't want to see the toolbar at all you can hide it by unchecking Toolbar in the Window menu (choose Hide Toolbar on Mac).

Let's take a look at what the buttons in the toolbar offer:

Using Star Ratings

- To add star ratings, click on the number of stars you want to assign to the photo(s). You'll notice them darken as you move your cursor over them.

- To change the number of stars assigned, click on the number of stars you want to change the rating to.

- To remove all stars click on the word "Rating."

Launches Nikon Transfer.

Focus Point places a set of red brackets on your photos to show where the camera focused. The brackets will only appear if you used auto focus. If manual focus was used then no brackets will appear. To hide the brackets click the button again.

This button would be darkened if the photo has a voice memo attached to it. The D60 doesn't have the ability to record voice memos.

Use the Rotate button to turn your photo 90 degrees clockwise or counterclockwise. Click and hold the button to choose which direction you want to rotate your photo.

Clicking this button will open the selected photo in Nikon's Capture NX software.

You can also print your photos directly from ViewNX. Click the print button to bring up the print dialog box which contains a basic set of printing options. You can print more than one photo at a time, so select the photos you want to print before choosing Print from the toolbar.

The Print As drop down menu offers three ways to print your photos:

1. Full Page: Fills the selected paper size with the photo.
2. Index Print: Print multiple images on each page. You choose how many pictures on a page.

3. Standard Photo Sizes: You pick from a set of print sizes (4 × 6, 5 × 7, 8 × 10, etc.).

Check the box next to Print Photo Information if you'd like details about your photo printed below it. Click the "Settings..." button to see what information can be added.

To change the paper size and printer click the "Page Setup..." button.

 The e-mail button brings up options for attaching one or more photos to an e-mail. ViewNX will use your e- mail software to create a new message and attach the selected photo(s) to it.

"Send as:" options:

Multiple photos means each photo selected will be a separate attachment to the e-mail. If index print is selected multiple photos will be placed on one page; you can choose how many photos per page. Each page of the index print is a separate attachment.

 The Slide Show button offers a quick way to create a slideshow to share your photos. Before clicking the button select the photos you want to include in the slideshow. ViewNX won't automatically play all the photos in the folder. For example, if you only have one photo selected the slideshow will just play that single photo.

The Slide Show dialog box gives you a variety of options for controlling how the slide show will run.

Toolbar: At the bottom of your monitor you can choose to have a toolbar, which allows you to control the progress of the slide show as well as what information is shown on the screen.

Transitions: You can choose if you want an effect such as fading or movement of the photos when the picture changes.

Using the checkboxes you can also choose how much, if any, additional information you have displayed about the photo during the

slideshow. During a slide show for family or friends you may not want to have any of the information visible. If you are using the slide show to review your photos you may find it useful to have some of the technical information displayed.

When the slide show finishes it will exit automatically unless you check "Repeat slide show."

During this slide show the toolbar is visible at the bottom and all possible information is displayed.

 Use the Convert Files button when you want to save a copy of one or more photos. You can use this feature to save an exact copy of a photo or to save a copy of a different size. This is useful when you've taken the photo at the highest quality setting on the D60 and the file is too large to e-mail. You can use Convert Files to save a smaller copy and then send the copy with the e-mail.

- "File format" gives you the option to save the copy of your photo as a JPEG or TIFF. JPEGs are compressed, while TIFFs are not. This means TIFFs will take up more space on your hard drive. Saving as a JPEG is fine for most uses.

- If you want to change the image size you can choose the pixel dimensions and ViewNX will maintain the original proportions of the image.

- "Compression Ratio" will be available if you are saving as a JPEG. I recommend a Good or Excellent Quality setting

- For most uses there is no need to remove camera setting information, XMP/IPTC information, or the ICC color profile.

- The options at the bottom of the dialog box allow you to choose where to save the photo(s), to create subfolders each time files are converted, and to rename the files.
- In the bottom left of the box ViewNX tells you how many photos will be converted.

LABELS

At the bottom of the window is a row of numbers.

The numbers are for labeling a photo with a number/color combination. One way to use the labels is to assign a category to them. "1" could be family photos, "2" landscape photos, "3" wildlife photos, and so on. To change the label assigned to each number go to the Edit menu and choose Options (for Mac choose Preferences from the ViewNX menu). Click "XMP/IPTC Information" from the list on the left. To change the labels from the defaults (Red, Orange, Yellow, etc.) uncheck the "Use default values" box.

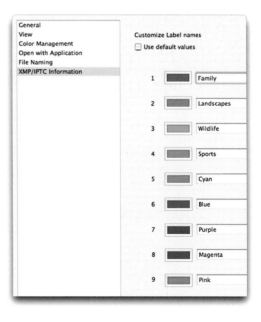

ADDING LABELS

- To label a photo simply click one of the numbers.
- You can only assign one label to each photo.

- To change the label click a different number.
- To remove the label click the zero.

RATINGS

Also at the bottom of the window is a row of stars.

The stars are for assigning a rating to your photos. They can be used to rank the quality of your photos. A one-star rating might be a low quality image and a rating of five stars could be one of your best photos.

Adding Ratings

- To add a star rating click the number of stars you want to assign to a photo. For example, if you want to add three stars you just need to click the third star.
- To change the star rating click a different star in the row.
- To remove the rating click the icon to the left of the first star.

TIP

To add the same label and/or rating to more than one photo at a time, select multiple thumbnails then choose the label and rating.

When you add a label or rating it will appear under the thumbnail photo. If you already assigned a label and/or rating (when downloading or using the IPTC palette) they will appear under the thumbnail automatically.

This photo has been labeled with a "1" and been given a three-star rating.

VIEWING AND SORTING

Above the thumbnail display are a series of buttons that give you different ways to view and sort your images.

Clicking the first icon gives you three ways to display your photos.

THUMBNAIL GRID

Thumbnail Grid only shows your photos as thumbnails. This view allows you to see the most pictures at once. Double-click a thumbnail to view it full screen.

IMAGE VIEWER

Image Viewer places a strip of thumbnails across the top with the selected image shown below. This arrangement allows you the most flexibility because you can scroll through thumbnails while getting a better view of your selected image.

Between the thumbnails and the large image are a series of navigation and viewing controls:

Arrow keys allow you to move to the previous or next photo.

You can use the drop down menu on the right to choose to display the histogram for the current photo.

To adjust the size of the image move the slider on the far right. To automatically make the image as large as possible, click the box icon on the left side of the slider.

TIP

In Image Viewer mode:

Double-click a thumbnail to switch to Thumbnail Grid mode.

Double-click the large image to switch to Full Screen mode.

FULL SCREEN

Full Screen fills your monitor with the selected photo. All menus and most icons are removed to give as much space as possible to your photo. The sorting options are taken away since there's just a single image. Use this view when you want to see a photo as large as possible.

The controls at the top of the screen are the same as those in the Image Viewer mode.

 Arrow keys at the top center allow you to move to the previous or next image while staying in full screen mode.

There is a drop down menu at the top right where you can choose to view the histogram for the current photo.

TIP

Ways to Exit Full Screen Mode:

1. Press the Escape key.
2. Click on the "X" in the top right corner of the screen.
3. Press Ctrl+W (Cmd+W for Mac)

To adjust the size of the image move the slider at the top right. To automatically make the image as large as possible click the box icon at the left side of the slider.

SORTING BY NUMBER LABELS

The number icons above the thumbnails look just like the numbers at the bottom of the window, but these are for sorting your photos by the number label assigned to them. The magnifying glass left of the numbers tells you these are for sorting not assigning.

For instance, click the 5 to see all your photos labeled with a 5.

You can also create a combined sort by clicking more than one number.

This combination would show you all photos labeled with a 2, 5, or 8.

SORTING BY STAR RATINGS

 The star icons above the thumbnails look just like the numbers at the bottom of the window, but these are for sorting your photos by the rating assigned to them. The magnifying glass left of the stars tells you they are for sorting not assigning.

To see the photos that have three stars click the third star. The window will say "Processing" while ViewNX is sorting. Once done the window will just show photos that have been assigned three stars.

TIP

- If you see the message "There is no file to display" this means there are no photos labeled with the number(s) you clicked.

- To deselect a number click it again.

- To clear a sort click the magnifying glass next to the number one.

Hilz_050507_0087.jpg ★★★ i
Hilz_050707_0801.jpg ★★★ i
Hilz_050807_2969.jpg ★★★ i

TIP

To clear a sort by star ratings click the icon next to the number one star.

You can also create a combined sort by clicking on more than one star; however, you have to choose a range of star ratings. For example, ViewNX won't let you just pick 1, 3, and 5 stars. You have to pick numbers that are next to each other such as 1–2, 4–5, and 2–3–4. The following selection means that any photos that have three, four, or five stars will be displayed:

CHANGING SORT ORDER

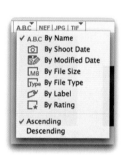

To the right of the stars is a drop down menu that has options for changing how your sorts are ordered. There are a variety of options ranging from alphabetically (By Name) to when you took the picture (By Shoot Date) to the rating or label.

SORTING BY FILE TYPE

The last sorting method is by file type. From the drop down menu you can choose what type of file(s) you want shown.

NEF = RAW files

JPG = JPEG files

TIF = TIFF files

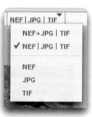

The default option is "NEF|JPG|TIF," which will show all the file types. If you want to see photos from only one of these file types select it from the bottom of the list.

TIP

Whenever you sort your photos (by label or rating) there is a message at the bottom of the window that says "Filtering On." This lets you know your photos are sorted and how many of the total are displayed.

Filtering On:123 of 2705 images displayed

The message above tells me that 123 images are visible out of a total of 2,705 photos in the folder.

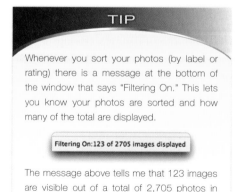

ADJUSTING THUMBNAIL SIZE

Move the slider between the + and − magnifying glasses to adjust the size of the thumbnail. You can also click on either magnifying glass to change the size. This slider is available in the Thumbnail Grid and Image Viewer modes.

CAPTURE NX

Capture NX offers an extensive set of tools to adjust your RAW and JPEG photos. Some adjustments can only be made to RAW files and will not be available when you're working with a JPEG. To give you an introduction to the capabilities of Capture NX we'll look at the features you'll use most often.

Capture NX has a number of palettes arranged on three sides of your screen. Each palette has its name written vertically. Just above the name of the palette is a little box with a + or − in it. These symbols tell you what will happen if you click the box. A plus symbol means the palette will expand and show the contents. If you click a minus symbol the palette will shrink and hide the contents. The boxes down the left side of your monitor probably look familiar. They're the same ones that are in ViewNX. Next to these vertical boxes is the browser used to find the photos you want to open in Capture NX.

BASE ADJUSTMENTS

After opening your photo the first adjustments you'll want to make are called the Base Adjustments. The center palette on the right side of your screen is the Edit List. The Edit List will show any adjustments you've made to your photo. You'll be using the Edit List a lot. Base Adjustments is automatically listed at the top of the Edit List. Click the triangle next to it to show the adjustments available. The list of Base Adjustments will vary depending on whether you are working with a RAW or a JPEG file.

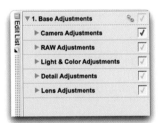

Base Adjustments for a RAW file.

Base Adjustments for a JPEG photo.

Click the triangle next to each category to see the adjustments within it. When you click the triangle next to a sub-adjustment an options box pops up to the left.

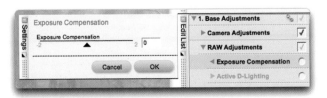

Exposure Compensation options box.

In the Edit List there's a check mark next to each adjustment (or sub-adjustment) that you've changed. To turn off the adjustment click the checkbox/circle. In the screen shot shown here all of the adjustments are checked.

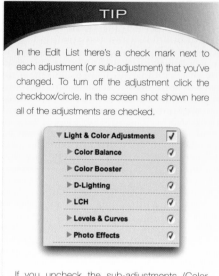

If you uncheck the sub-adjustments (Color Balance, Color Booster, D-Lighting, etc.) you'll turn off the effect of those individual adjustments. If the box next to Light & Color Adjustments is unchecked it will remove the checks from all the adjustments below. What makes this system convenient is that you can always check the box/circle again to bring the adjustment back. Checking and unchecking adjustments is a quick way to see what your photo looks like with and without the change.

Here are some tips and descriptions of the Base Adjustments you'll use most often.

- RAW Adjustments (for RAW files only, not available for JPEGs)

Exposure Compensation: Increase or decrease your photo's exposure (how bright or dark it is).

White Balance: Change the white balance from what it was when you took the picture.

- Light & Color Adjustments

Color Balance: Adjust brightness and contrast. The color sliders can be used to remove an unwanted color cast on the image. If it is a RAW photo and you have a strange color cast, first try changing the white balance to correct it.

Color Booster: Increase or decrease the saturation of the colors. If it's a photograph including people, check the box for "Protect skin tones" because too much saturation can make skin tones look unnatural.

D-Lighting: Brings out more detail in highlight and shadow areas of your photo. Choose "Better Quality" for more control over how the shadows and highlights are adjusted.

Levels & Curves: A standard adjustment useful for most photos is to bring the black and white sliders in to the edges of the histogram.

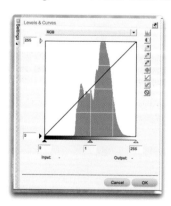

Initial histogram, no adjustments.

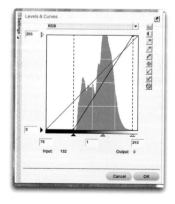

Black and white sliders brought in to the ends of the histogram.

Photo Effects: The drop down menu offers the options to change the color cast (Enhance Photo) as well as switch the photo to black and white, sepia, or add a color tint.

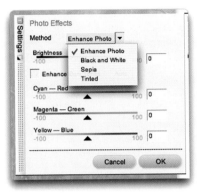

Photo Effects options.

- Detail Adjustments

Noise Reduction: If you took a picture at a high ISO you may notice a grainy or speckled appearance in some parts of the image (especially the shadows). The noise reduction setting can help reduce the grainy look.

Unsharp Mask: Increases the sharpness or definition of the details in a photo. In a way it makes your photo appear to be more in focus. This may seem odd since it's called "unsharp," but that's what it does! However, you do need to start with a picture that's in focus. Unsharp Mask won't take an out-of-focus image and make it in focus. Sharpening is particularly important to do prior to printing.

Auto Red-Eye: When set to Automatic this setting will locate and remove red-eye in your photo.

- Lens Adjustments

Vignette Control: If there is vignetting in your photo (darkening around the edges) use this adjustment to reduce or remove it.

ADDITIONAL PALETTES

Above the Edit List palette is the Bird's Eye palette. It shows you a thumbnail of your photo. If you are zoomed in and the photo is larger than the window, the Bird's Eye will show a red box around the part of the picture you are seeing. To move around the photo you can click and drag the red box around the Bird's Eye thumbnail.

Below the Edit List is the Histogram palette. You can view the RGB histogram or the individual color channels.

TOOLBAR

The toolbar is a series of small palettes across the top of the screen each with a set of adjustment tools. The following is an overview of how you can use them to adjust your photos. It's not intended to be step-by-step instructions for how to use the adjustment tools, but an introduction to what Capture NX has to offer.

Direct Select Tool: Use to select objects such as control points, images in the browser and steps in the Edit List.

Hand Tool: If you have zoomed into your image and it's too large to fit on the screen you can use the hand tool to move to different parts of your image. Click and drag on your photo to move it around.

Zoom Tool: The Zoom Tool changes your cursor to a magnifying glass with a "+" inside it. Click on your photo to zoom in. To zoom out press and hold the Alt key (Option for Mac) while clicking on your photo. The magnifying glass will now have a "−" inside it. When you release the Alt (or Option) key you'll be back to "zoom in" mode.

TIP

Hand Tool Shortcut:

To quickly use the Hand Tool press and hold the space bar. Your cursor will change to the hand and as long as you hold down the space bar you can use the Hand Tool. Let go of the space bar and you'll be back to the tool you were previously using.

Rotate Tool: Turns a photo 90 degrees clockwise or counterclockwise. Click and hold the button to choose which way you want to rotate the photo.

Straighten Tool: If your photo is askew you can fix it using the Straighten Tool. Perhaps you have a sunset photo where the horizon is not straight. You use the Straighten Tool to draw a line along the horizon, which tells Capture NX that this line should be level. The photo is then rotated to make the horizon straight. Be aware that to straighten a photo cropping is required, so you'll lose some of your photo around the edges. The more a photo must be straightened the more it will be cropped.

Crop Tool: Click and drag to draw a cropping box. After creating a box you can click and drag on the black boxes around the edges to change its size and shape. To move the box (but keep the size of the box the same) click and drag in the center of the box. To complete the crop press Enter, to cancel the crop press the Esc key.

Black, White, and Neutral Control Points: The three eye droppers represent black, white, and neutral from left to right. You can use them to identify black, white, and neutral tones in your image. If you don't actually have areas of pure black or white in your image using those eye droppers can lead to dramatic, often unwanted, changes in the appearance of your photo. Placing a neutral control point on a neutral or middle tone area will remove color casts from a photo.

Color Control Point: This is a powerful feature of Capture NX. It allows you to selectively adjust individual colors within your photo. They're easy to use and give you a lot of control over retouching your image. You can use control points with JPEG or RAW files. After clicking the control point button, click the color you want to change in your photo. It could be a person's face, the sky, or a flower. Once you click on your photo four slider bars appear.

When you drag the top slider you'll see a circle appear. As you drag the slider the circle becomes smaller or larger. The size of the circle reflects how large an area you want to adjust. A small circle will change an area close to the spot you chose; a large circle will affect more of the photo. The remaining sliders are labeled B, C, and S. B = brightness, C = contrast, and S = saturation. Using these three sliders you can increase or decrease the amount of brightness, contrast, and saturation in your targeted area. You can add multiple control points to a photo.

Here's a before and after comparison of a photo adjusted using control points. I used control points to darken the background and darken the flower on the right as well as lighten and add saturation to the flower on the left. In the adjusted photo the viewer's attention is focused on the left flower because it's brighter.

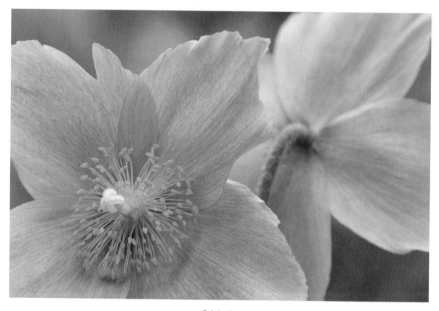

Original.

Adjusted with Control Points.

Red-eye Control Point: Click on the subject's eye where you want the red-eye removed.

Selection Brush: You can use the selection brush to paint over areas that you want to change in your photo. Next go to the Edit List and choose what adjustment you want to apply to the area you painted with the brush. The selection brush can also be used in combination with the Lasso/Marquee, Selection Gradient, and Fill/Remove Tools. You would use those tools first then use the brush to further fine-tune how the effects are applied.

Lasso & Marquee Tools: These tools are for drawing selections around certain areas of a photo. Click and hold the button to see all the choices available. Once you select part of your photo, go over to the Edit List where you can choose what type of adjustment you want to apply to the selected area.

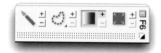

Selection Gradient: The gradient tool allows you to adjust an area of your photo by creating a gradual transition. At one end of the gradation the effect you choose will be very strong and at the other end the effect will be faint. Use the gradient tool to draw a line on your photo from where you want the effect to start to where it should end. Next go to the Edit List and select the adjustment you want to apply to the gradient area.

Fill/Remove Tool: Clicking on the fill/remove button will select the entire image, then over in the Edit List you can choose what adjustment you want to add.

Part 3

The Light

USING NATURAL LIGHT

No matter what you're photographing, the light is a key component. Without light, from some source, you wouldn't have a photograph. It affects the appearance of your subject, creates a mood, and directs the viewer's eye. In this section we'll look at photography using natural light.

TIME OF DAY

What time of day you take a picture outside has an enormous impact on the appearance of your photograph. As the sun moves through the sky the quality of the light changes. Early and late in the day are the best times to be out photographing. Even before sunrise you can have rich warm colors in the sky, lighting up scattered clouds. In the early morning and late afternoon the sun is low on the horizon. When it's at this low angle it throws a warm light over the landscape and everything from trees to sign posts cast long shadows. As the sun moves higher up in the sky you lose the warm light and long shadows.

> **TIP**
>
> Rule of thumb when working with sunlight: The light is good when your shadow is longer than you are.

SUNRISE AND SUNSET

Look for vibrant colors in the sky at sunrise and sunset. The warm hues of yellow, orange, red, and pink add dramatic color to a landscape. Include any interesting cloud formations that

roll through the sky. Some of the best sunrise and sunset photographs are taken before the sun is above the horizon or after it has dropped below the horizon.

Fading color at sunset.

Besides warm light at sunrise, water will also be calm, making it perfect for reflections.

MORNING AND AFTERNOON

For a few hours after sunrise and before sunset, the light is still warm, attractively lighting many subjects. In the morning and late afternoon the sun is lower in the sky.

Late morning offers warm light, as well as a rich blue sky.

In the morning the angle of light is still low enough to produce dramatic lighting.

MID-DAY

The middle of the day is generally the worst time of the day to photograph outside. With the sun high overhead the light is harsh and contrasty. This type of lighting appears flat and is not an appealing look for subjects.

DIRECTION OF LIGHT

FRONT LIGHTING

When the light is coming from behind you (over your shoulder), your subject is front lit. Front lighting is good for showing details because it evenly lights up the subject.

Front lighting throws a warm, but even light on this bow of the boat.

The sun over my shoulder strongly lights the front of the building while the stormy clouds above create a dramatic backdrop.

SIDE LIGHTING

Side lighting is when the light is coming from your left or right. You'll find side lighting in the morning and late afternoons when the sun is low in the sky. It's good for emphasizing texture and showing detail. It can help define the shape of many subjects whether you're photographing a landscape or a city. Shadows are more apparent when there is side lighting.

Side lighting creates shadows that help push the eye across the image.

The shadows help fill in the right side of the composition.

BACK LIGHTING

Back lighting occurs when the sun is behind your subject. Back lighting can be dramatic. You can use back lighting to create silhouettes. If the backlighting is strong enough it can create a glow around your subject called rim lighting. With backlighting it can be more challenging for the camera to properly expose your photograph. Be sure to use the monitor to review your image to see if you need to make any adjustments.

Use backlighting to create graphic silhouettes.

Backlighting gives a glow to the leaves on the tree and the Spanish moss hanging in its branches.

DIFFUSED LIGHTING

Cloudy days are also a great time to go outside and photograph. Overcast days produce a diffused light that is soft and even. You retain excellent detail in the highlights and shadows of your subject. Diffused light lets you avoid the high contrast of direct sunlight that can be a problem for some subjects. On cloudy days you could spend the whole day photographing outside because you don't have to worry about harsh mid-day lighting.

Diffused light allowed me to retain the detail, avoiding any bright areas on the pale clematis petals.

Soft light on the chain helped retain detail in the shadows at the top of the image. The isolated composition removes any references for scale. Each link of the chain is at least six inches long.

INCLEMENT WEATHER

If it isn't sunny outside it doesn't mean it's a bad time of day to go out and photograph. Inclement weather such as fog, rain, and snow offer some unique shooting opportunities. Fog can magically transform a landscape. With fog hanging in the air it can make a scene mysterious and moody.

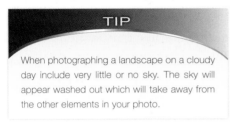

When photographing a landscape on a cloudy day include very little or no sky. The sky will appear washed out which will take away from the other elements in your photo.

When plants and flowers get wet their colors become more saturated. Getting out to photograph right after the rain stops is ideal. Even photographing in light rain is manageable. Just make sure you're dressed for the conditions. Aside from a rain jacket to keep yourself dry you want to have your camera protected too. While you could bring along a plastic bag, a variety of companies make rain covers for cameras. They include FM Photography (Shutterhat), OP/TECH USA (Rainsleeve), and Kata (GDC Elements Cover).

If you're going out in the snow you definitely want to bundle up. If you stay warm you'll want to stay out longer photographing. It's no fun to stay out shooting when you're cold and wet. Photographing while it's snowing can give your photos a different look with the snow suspended in the air. Or get outside when the snow stops while everything is covered in a pristine blanket of white.

The fog wraps around the trees drawing your attention to the treetops emerging from the mist.

Just after it rained the lily pad is covered with water drops along with a lone frog.

Look for details after a snowstorm, such as this rock at the edge of a frozen pond.

LIGHTING COMPARISON

A location or subject can look quite different depending on the type of lighting. Take a look at these examples and how the feeling of the photo changes with the light.

SIDE LIGHTING VS. FRONT LIGHTING

By moving my position I was able to photograph this small scene with both front lighting and side lighting. In the front lighting photo the azaleas and Spanish moss are evenly lit all the way across the image. From the side the shadows are much more apparent for a more dramatic feel.

Front lighting.

Side lighting.

DIFFUSED LIGHTING VS. DIRECT SUNLIGHT

In these two photos the composition is the same. All that changed was the lighting. The leaf and water drops were shaded, then the sun poked through between some branches and all of a sudden they were sunlit. The direct sunlight highlights each water drop making them more easily visible than under diffused lighting.

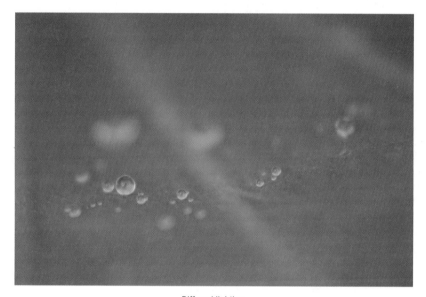

Diffused lighting.

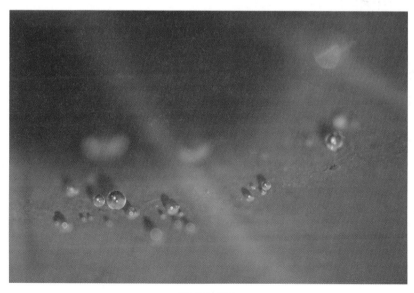

Direct sunlight.

Lenses

Lenses are one of the tools photographers use to share their view of the world. Just as changing your aperture affects the appearance of your subject, so can the choice to use a wide-angle lens vs. a telephoto lens.

The photos below, taken while standing in the same place, give you an idea of how much you can change just by zooming in or using different lenses. The lens focal length used for each photo is listed below each photo.

27 mm

50 mm

105 mm

300 mm

600 mm

ZOOM LENSES

With a zoom lens you can change focal length by turning a ring on the lens, which is called a twist zoom. On some older lenses you would zoom by pushing and pulling the lens forward and back (a push/pull zoom). Zoom lenses give you a lot of flexibility because you can adjust your composition by turning the zoom ring. You may not have to move closer or further from your subject if you can get the shot you want by zooming in (a closer view) or zooming out (a wider view). The zoom lenses made today are very good quality and can produce excellent photos. They can be a compact way to travel because you get many focal lengths in a single lens. Think of it this way: with a 17–55 mm lens you have a 17 mm lens, a 24 mm lens, a 35 mm lens, and a 50 mm lens all combined into one lens. There are a variety of zoom lenses available. Autofocus zoom lenses have two rings on the outside that rotate. One is the zoom ring and the other is the focusing ring. The zoom ring is usually larger and often toward the back of the lens, with the focusing ring closer to the front. In some lenses the focusing ring is actually the front of the lens.

FIXED FOCAL LENGTH LENSES

Fixed focal length lenses don't zoom, they remain at a single focal length. With these lenses you have to "zoom with your feet," meaning you have to walk closer to or further from your subject to change how much you see. Fixed focal length lenses are also called prime lenses. They are often smaller and lighter weight than zoom lenses because

A zoom lens allowed me to easily frame a tight shot of this lily pad in the middle of a pond.

their construction doesn't require as many pieces of glass (called elements). Prime lenses have a focusing ring.

MAXIMUM APERTURE

Every lens has a maximum aperture, which is the largest possible opening for the lens. It's often f/2.8, f/3.5, or f/4. The maximum aperture is listed on the lens among the string of letters and numbers that make up the name of the lens. The 12–24 mm lens is listed as "AF-S DX Zoom Nikkor 12–24 mm f/4G

24 mm fixed lens.

IF-ED." Near the end of that lengthy name you see f/4, telling you the maximum aperture is f/4. Some zoom lenses will have a hyphenated aperture such as f/3.5–5.6. This is called a variable aperture. It means that at the wide end of the zoom range the maximum aperture will be f/3.5, but when you zoom to the longest focal length the max aperture will be f/5.6. Nikon's 18–135 mm lens has a variable aperture of f/3.5–5.6. At 18 mm the maximum aperture is f/3.5, but when you zoom to 135 mm it becomes f/5.6. In between 18 and 135 mm the aperture gradually shifts from f/3.5 to f/5.6. You don't need to use a lens any differently because it's a variable aperture lens. Lenses that are variable aperture are smaller and lighter weight than a comparable lens with a fixed maximum aperture.

FOCUSING

Regardless of whether the lens is a zoom or fixed focal length, almost all current lenses will have the ability for you to either autofocus or manually focus. The D60 does have one restriction regarding autofocus. For the camera to be able to use autofocus you must use AF-S or AF-I type lenses. These lenses have an autofocus motor within the lens. The good news is that almost all of Nikon's current autofocus lenses are AF-S lenses. So it's nothing to be worried about, just something to be aware of when you're choosing a lens. To see if a lens is an AF-S or AF-I model take a look at the name of the lens. Here are a couple examples of AF-S lenses: 18–135 mm f3.5–5.6G ED-IF AF-S DX and 70–300 mm f4.5–5.6G ED-IF AF-S VR. If you use a lens that isn't AF-S or AF-I you can still use manual focus, but autofocus will be disabled.

Whether you focus on your subject using autofocus or manual focus is largely personal preference. Autofocus is a quick way to bring your subject into focus because the camera does the work for you. If autofocus can't lock onto your subject then try manual focus. When doing close-up or macro photography manual focus is usually a better choice. With close-up photography you often want to be very precise with where you focus on your subject. For instance if you are

photographing a small flower, do you want to focus on the center of the flower or the edge of the petals? The camera won't know so you're better off manually focusing to place the focus on just the right spot. In comparison if you're photographing a landscape autofocus will do much better bringing your scene into focus.

By using manual focus I was able to precisely focus on the center of the flower.

Most Nikon autofocus lenses have a switch on the side of the lens to select autofocus or manual focus. The switch with be labeled in one of two ways: (1) A and M or (2) M/A and M. "A" mode is only autofocus and "M" is only manual focus. "M/A" means that if you are in autofocus you can turn the focusing ring on the lens and it will automatically switch to manual focus. In "A" mode you won't be able to turn the focusing ring.

M/A and M focus switch.

> ### TIP
>
> Use the M and A switch on your lens to quickly switch between manual and autofocus. In Part 1 we looked at how you can change from autofocus to manual focus using the Quick Settings Display. To change modes even faster leave the camera set to autofocus, then when you want to use manual focus just slide the switch on your lens to M. The D60 will automatically change to manual focus mode. Slide the switch back to A (or M/A) when you want to return to autofocus.

WIDE-ANGLE LENSES

Wide-angle lenses range from 12 to 35 mm. Zooms will include some portion of this range.

12-24 mm.

Wide-angle lenses can be used to photograph a landscape where you want to capture the whole scene. They emphasize depth in a scene by showing the distance between different elements such as those in the foreground and background.

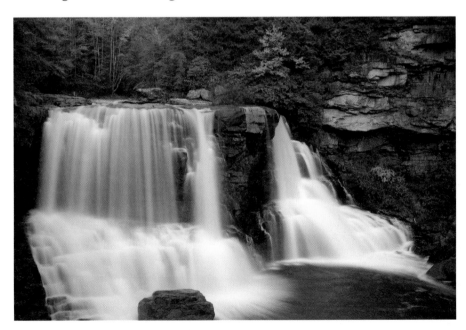

They can also be used to show a small piece of a landscape and emphasize a part of the scene that is very close to you.

Wide-angle lenses will make what is closest to the lens appear larger than what is further away. In the next photo, all the rocking chairs are the same size, but the one in front seems larger than the ones in the back.

STANDARD LENSES

A 50 mm lens is considered a standard focal length lens. Fixed focal length 50 mm lenses are available and they're excellent quality, but

they aren't AF-S lenses, so they would only function as a manual focus lens. There are many zoom lenses that include the 50 mm focal length.

TELEPHOTO LENSES

The telephoto range goes from around 70 to 200 mm. Telephoto lenses allow you to photograph a small piece of a landscape, a portrait, or capture a close picture of something that is far away. They also visually compress the elements in your photograph, which makes everything seem closer together than it really is. There are many zoom lenses that include some or all of this telephoto range.

The 70–300 mm covers the whole range of the standard telephoto and then some.

Using a telephoto lens to photograph this river makes it look like the cascade is right in front of the trees.

SUPER TELEPHOTO LENSES

Super telephotos range from 300 to 600 mm. Lenses in these focal lengths are usually fixed focal lengths. Common focal lengths are 300, 400, 500, and 600 mm. There are some zooms that reach into this range, but not many. You can use these lenses in the same manner as shorter telephotos — isolating parts of a landscape and capturing close shots of far away subjects. Super telephotos will compress the elements and depth in a photograph even more than regular telephotos.

Super telephotos are more often used for photographing wildlife and sports, specifically the 500 and 600 mm lenses. With animals and athletes you often can't get close. So if you don't want a photo where the person or

Small landscape details can be easily isolated with a telephoto lens.

I used a 300 mm lens to isolate the boat and create the feeling that there's nothing else around it in the water.

animal is very small you need a long lens to get a tight shot. If you look for the press photographers at a major sporting event you'll see they all have long lenses on monopods ready to capture the action.

Using a 300 mm lens allowed me to capture a good photo of these alligators while staying a safe distance away.

ZOOM LENS CHOICES

Zoom lenses come in so many varieties they don't fit neatly into the wide-angle, standard, telephoto, and super telephoto groups. Often a zoom lens will include focal lengths from more than one group. This is a good thing because you don't have to carry around lots of different lenses. You can probably do just fine with a couple lenses depending on what you like to photograph. A number of Nikon zooms go from wide-angle to the short or mid-telephoto range. A few examples are: 16–85 mm, 18–55 mm, and 18–135 mm.

18–135 mm.

There are also high-power zoom lenses that start between 50 and 80 mm, then go up to 200 to 400 mm. Nikon's lenses in this range include the 55–200 mm, 70–300 mm, 80–200 mm, and 80–400 mm.

55–200 mm.

A great quality all around lens is Nikon's 18–200 mm. With this lens you're covered all the way from wide angle through telephoto. It even has the vibration reduction (VR) technology, a great benefit when photographing handheld. More info on VR coming up.

HANDHOLDING THE CAMERA

If you use too slow a shutter speed when handholding the camera your pictures will not be sharp. How do you know what a good shutter speed is? A good rule of thumb is to take the inverse of your lens' longest focal length. For example, if you have an 18–135 mm lens you would take 135 and make it 1/135. Then pick the closest shutter speed to 1/135, which is 1/125. The slowest shutter speed you should use with your 18–135 mm lens is 1/125 of a second. Now this method is not a definitive answer, but it gives you an idea of where to start. Do some tests of your own, taking pictures at progressively slower shutter speeds and see when they become blurry. The longer the focal length of the lens, the faster your minimum shutter speed needs to be.

The bright sunlight coming from above the clouds made it easy to get a shutter speed fast enough for handholding.

VIBRATION REDUCTION

Some of Nikon's lenses have a feature called vibration reduction (VR). Vibration reduction is an image stabilization technology that helps to correct for your movement (such as hand shake) when you're taking a picture. There is one element (piece of glass) in the lens which moves, working to compensate for your movement. The benefit of VR is you can take handheld pictures at shutter speeds that are two to three stops slower than what you would use with a non-VR lens. Let's say you have a regular 18–135 mm lens, which means the slowest shutter you'd want to use is 1/125 of a second. If that were a VR lens you could reduce that minimum shutter speed to 1/30 or 1/15 of a second. 1/125 vs. 1/15? That's a big difference that gives you a lot more flexibility with when you can photograph.

If a lens has VR there will be a sliding switch on the side of the lens to turn VR on and off. Turn VR off if you're photographing on a tripod. The normal/active switch below the On/Off is also related to VR. In most shooting situations (when using VR) you will set the switch to Normal. You would use the active setting if you are taking photos from a moving vehicle.

VR switches on a lens.

Vibration reduction can help you get a sharp picture while handholding the camera in dim lighting.

LENS HOODS

Lens hoods are an accessory that comes with most lenses. They attach to the front of the lens and extend out. The shape of the lens hood is related to the lens it's made for. Here are a few examples:

A wide-angle lens will have a short lens hood; a telephoto lens will have a longer one. A wide-angle lens can't have a long lens hood because the edge of the lens hood would actually be in the picture. You'd see the edge of the hood when you look through the lens. This is because the lens has a wide angle of view and you see a lot of what is out to the sides of the lens. A telephoto lens has a narrower angle of view, it does not see as much "out to the sides," so the lens hood can extend further and not interfere with what you see.

The primary benefit of a lens hood is preventing lens flare. Flare is caused by the sunlight coming directly into the lens and bouncing of the elements inside the lens. Lens flare is most likely to occur when it's sunny and the sun is in front of you or just off to either side. Wide-angle lenses are more susceptible to flare than telephoto lenses because they can't use as large of a lens hood. Flare can be very obvious as one or more circular or polygonal shapes. It can also be more subtle in the form or a slight haze across all or part of your image. Keeping the lens hood on can help minimize flare. A lens hood won't always stop flare, particularly if you are photographing straight toward

the sun. When the lens hood isn't solving the problem, try holding your hand or hat to block the flare. What you're trying to do is shade the front of your lens without getting your hat or hand in the picture.

Lens flare: in addition to the flare circle notice how the flare creates a haze, washing out the rich color.

Lens hood used and lens shaded with hand.

TIP

Preventing flare isn't the only thing lens hoods are good for. They can also help protect the front element of your lens. Keeping the lens hood attached makes it less likely that something will be able to bump into the glass on the front of your lens.

TIP

If you're photographing in the rain or snow a lens hood can help keep the water (or snow) off the front of your lens.

While photographing in a snow storm using a lens hood kept the snow off the front of my lens.

MACRO LENSES

If you like to take close-up pictures or photograph subjects that are very small, you want to consider a macro lens. Nikon makes three lenses for close-up photography, which they call "Micro" lenses: 60, 105, and 200 mm. These are all fixed focal length lenses. Macro lenses are specifically designed for close focusing. Every lens has a minimum focusing distance. To see how close your lens can focus, switch to manual focus mode then turn the focus ring to its smallest number. Now look through the viewfinder and start moving closer to an object. As soon as the object is in focus stop. That's the lens's minimum focusing distance. If you get any closer you won't be able to bring the object into focus. If you had a macro lens to do the same test with (on the same object) you'd find that you could get a lot closer and still keep the object in focus. This capability allows you to photograph small subjects or little details of larger subjects.

105 mm macro lens

When you can get very close to a subject you can find interesting abstract patterns.

A macro lens allows you to capture small details like the center of this Echinacea.

Each of Nikon's macro lenses will produce excellent quality images. The benefit of using a longer focal length lens is you gain more working distance. You don't have to be as close to your subject to get the same photo. Let's say you were using the 60 mm macro lens and you had to be 1 foot away from your subject to get the picture you want. If you used the 105 mm lens you could be 1.6 feet away from the subject and get the same shot. Using the 200 mm lens you could be almost 3 feet away and capture the same image. A longer focal length would allow you to take a close-up picture of something even if you couldn't get really close to it. Also, if you were photographing a small animal such as a butterfly you may not want to get too close as it might fly away.

Part 5

Composition &
the Subjects

COMPOSITION TECHNIQUES

SUBJECT PLACEMENT AND THE RULE OF THIRDS

Often we place our subjects in the center of our photographs. It's an easy place to put the subject and easy to get the subject in focus. However, in terms of creating a compelling and interesting composition, the center of the photo is not a great place for the subject.

To start thinking about other places to put the subject there's a concept that goes by a couple names: the Rule of Thirds or Power Points. The idea is to divide your photograph into thirds both horizontally and vertically. It's like laying a tic-tac-toe board over your image.

This creates four intersecting points: top left, top right, bottom left, and bottom right. Each of these points is a "power point," meaning they're good places to consider for placing your subject. Use these points as a compositional aid. The idea is to give you a rough idea of where to consider placing your subject. When you've chosen a subject and are selecting a composition keep the power points in mind. Move the camera around to place your subject near those four areas and see what looks good to you. In most cases one of those areas will be a better place for your subject than the center of the photo.

The center of interest in these compositions was placed near one of the power points.

Does this mean you should never place your subject in the exact center of your image? No. But if you do, you should have a specific reason for doing so. Consider this image where the power lines are in the center. The purpose of placing it in the center was to emphasize the symmetry and graphic design.

COMPOSITIONAL TIPS

- Another element to avoid placing in the middle is the horizon line. When you're photographing landscapes try placing the horizon above or below the center of the image.

The foreground of the composition is emphasized by placing the horizon near the top.

- Lines can create a sense of movement and direct the eye. Often lines will lead the viewer's eye through an image, so it's important to be aware of lines when you compose a picture.

The curving lines of the road lead your eye back to the building.

- Looking at the world around you many things are made up of shapes. You can create eye-catching images by making shapes a primary part of the composition.

- Use color to your advantage. Put together complementary colors for pleasing color combinations or use a single bold color that dominates.

The vibrant color of the azalea immediately grabs the viewer's attention.

- Foreground objects add depth and scale to landscape photos.

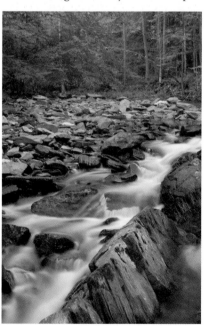

WHILE YOU'RE OUT PHOTOGRAPHING....

- Walk around your subject to look at various angles/perspectives.

- Think about what's the best light for the subject (diffused, side lighting, back lighting).

- Try photographing the same scene/subject with different lenses (or different focal lengths on a zoom lens).

- Take both vertical and horizontal photos.

- Adjust your perspective: take pictures from up high and down low.

- Take multiple photos of a single subject/scene (there isn't just one right shot).

- Have clear center of interest, so it's clear what your subject is.
- Avoid distracting backgrounds.
- Include little or no sky in your composition if it's an overcast day (it will just appear as a white mass with no detail).

PORTRAITS & PEOPLE

- To achieve a soft, out-of-focus background when photographing one person use a wide aperture (f/4, f/5.6).
- Be ready to take the shot when the right expression comes along.
- Be aware of what's happening behind your subject. You don't want a background that's taking attention away from the person. If you see distracting background elements move to a different position to try and eliminate or minimize them.

- Try environmental portraits, where you show the area around where the person is.
- Take close portraits where the person's face or head and upper body are filling the viewfinder.
- The more photos you can take of someone, the better chance you have at capturing quality images. It's hard to take just one or two photos and have those turn out to be the best pictures. If you spend some time photographing a person it's often the photos near the end of the shoot that are the best. By that time both you and the subject have relaxed and the good pictures come easier.

LIGHT

- Soft, even lighting gives a pleasant look for portraits (overcast days or if people are in the shade).
- Avoid "top lighting," when the sun is overhead shining down on your subject. The result is not flattering: around the eyes is very dark along with heavy shadows under the nose and chin. This is made even worse if the person is wearing a hat, because the hat will also cast a shadow on the person's face.
- If you must photograph people when the lighting is casting harsh shadows use the D60's flash to help fill in the shadows. You'll want to reduce the power of the flash (fill flash) so that the light from the flash isn't stronger than the sunlight.
- Avoid having people looking into the sun when you're taking their picture because they'll be squinting.

POSING

- Try posing your subject. At first it can be intimidating to tell someone where to sit or stand, where to look, where to place their hands, etc. The more pictures you take where you pose the subject, the more comfortable you'll become with it. You'll also develop a better sense of what poses work best for which people. At first just try a few poses and vary the types of pictures you take of your subject. Have him/her sit for some pictures and stand for others. Take some pictures with your subject looking at the camera as well as looking slightly to the left and right. As you're taking pictures try different framing: head shots, head and shoulder, waist up, full body. Also remember to take both vertical and horizontal photos.

- Look for an angle or perspective that is flattering to the person.

- For posed portraits people often lift their chin up, ask your subjects to lower their chin a little and they'll have a better appearance.

PHOTOGRAPHING STRANGERS

- Be respectful and courteous.

- Ask permission to photograph if you'll be taking the photo from a close distance. If someone says no, respect their answer and don't take a picture.

- Tell people why you want to photograph them. Many people are flattered to have their photo taken. Compliment them so they feel good about your interest in photographing them.

- Talk to them first to "warm them up."

- People find long/large lenses intimidating. Don't use a long lens if you are going to be close to the people you're photographing.

- Be friendly, smile a lot, and thank the person afterwards.

- If you're far away with a telephoto lens it may not be necessary to ask permission if the person isn't aware you are taking their photo.

- Go to places/events where people are more likely to be open to being photographed such as parks, festivals, parades.

PHOTOGRAPHING CHILDREN

- Always be ready to capture the fleeting moments. The best photo could be a brief expression or action.
- Move down to their level.
- Spend time with them so they are more comfortable with you photographing them.
- A great time to photograph kids is when they are doing something else: playing, eating, playing a game, drawing, doing a project. Then they're paying attention to the activity and not you and your camera.
- If possible use natural light and avoid the use of flash. Your photos will have a more natural look and the use of flash may distract your subject.
- Certainly ask permission before photographing a stranger's child.
- If you're arranging a photo session, solid colors for clothes work well, soft colors too. If the colors are too bold and vivid they can take away from the child.
- Try giving a prop to a child; just something for them to play with while you photograph. This will help take the attention away from the fact they're being photographed. A prop can be something you bring with you or a toy they have.

TRAVEL

- Do some research ahead of time to know a bit about the area, culture, and people. This will put you in a better position to seek out interesting photos. You'll also know if there are any major events, such as festivals, taking place while you're there.
- Once you arrive go to a gift shop or other tourist outlet and check out the postcards. From the postcards you can find out what the local sights are and maybe even get some ideas about how to photograph them.
- Consider how much camera equipment you want to carry. If you'll be walking around all day you may not want to be weighed down with lots of gear. Your D60 plus a wide-angle and telephoto lens will suffice for most photo opportunities.

Look for interesting details when you're traveling.

- Strive for variety in your photos: use wide and telephoto lenses, take verticals and horizontals, shoot the wide scene and the details.
- Photograph the landscape, especially any notable landforms, as well as local plants and animals.
- You may travel somewhere that has a well-photographed famous landmark. Don't let that dissuade you from photographing it yourself. It's

your trip and it's worth capturing images of where you go and what you see. Try photographing the landmark in a way that it isn't normally seen. Look for an unusual perspective or photograph interesting details of the landmark instead of the whole thing.

- Look for details that reflect the towns and cities you visit, such as architectural features, signs, and food or crafts at a market.
- Also capture the wide shot to show the overall view of the area.
- Photograph the locals, look for interesting expressions and clothing representative of the location.
- Visit a variety of areas: monuments, shopping areas/markets, landmarks.
- Get up high for a different perspective (skyscraper, church, bridge).
- In a city try photographing the buildings and streets from around sunset and afterwards when the sky is dark blue, but not yet black. At this time of day you'll still have color in the sky but you'll also be able to record building and streetlights. Metering for this type of exposure can be tricky. Check your monitor and histogram after an exposure to see if you need to make adjustments before the next photo. This type of shooting situation may require slow shutter speeds and a tripod to keep the camera still.

Experiment with different perspectives to give a fresh look to your photos.

PETS AND ANIMALS

Similar principles apply to photographing pets or other animals. You can usually just get a lot closer to your pet than a wild animal! Because of this when photographing your pet you really don't need a long telephoto lens.

- Get down to their level. This perspective looks more natural than standing above looking down.
- Look for good lighting conditions.
- Focus on the eyes.
- Be ready! You can't expect pets or wild animals to take direction like a person.
- Look for the humorous behavior or an interesting pose.

Photograph your pets down on their level for natural looking perspective.

- Telephoto lenses work best for wildlife so that you can take the picture from further away.
- Small animals such as birds will be difficult to photograph without a long telephoto lens. You can get a sharp shot of them, but they may be very small in the photo.
- Short or moderate telephoto lenses can do a great job with larger animals such as deer, horses, dogs, etc.
- For animals in the wild your photos don't have to be tight portraits. Try taking environmental portraits where you show the animal in its habitat.
- Zoos aren't a bad place for animal photos either. They're convenient and have lots of animals to choose from. Try for a portrait shot to minimize the area around the animal. Use a large aperture and focus on the animal's eyes. You can sometimes even photograph through the bars on a cage, and by using a large aperture the bars won't be noticeable.

- Whether it's your pet or a wild animal anticipating their action and reacting quickly is key. Just like photographing people it can be the fleeting moments that are the best pictures.

- To practice wildlife photography visit a local park and photograph the wildlife there. Squirrels may not be an exotic subject but they can test your reflexes and give you some good practice.

Wildlife might not stay still very long, get your shot when you have the chance!

ACTION

- Recommended settings: set focus mode to continuous (AF-C), AF-area mode to dynamic area, and release mode to continuous so you can fire off a burst of photos at a time.

- To get a fast enough shutter speed you may need to raise you ISO to 200 or even 400 depending on the lighting.

- Use a telephoto lens. One in the range of 70–200 mm is a good starting point.

- Longer lenses are good, too, but they are larger and more expensive.

- Use fast shutter speeds to freeze the action (1/250, 1/500, or faster depending on the speed of your subject).

- Try slow shutter speeds to create a motion blur (start with shutter speeds between 1/30 and 1/8 of a second).

- The closer you can get to the action the better, the larger you can make the subject in the frame the better.

- Look for the best place to photograph from, ideally a location where you have a clear view of the action. If you can visit where you will be photographing ahead of time you can scout out potential shooting locations.

- As the action is happening follow your subject in the viewfinder, then you're ready to take a picture when something interesting happens.

- Try to anticipate the action or the peak moment when you should take the picture. If you see the peak of the action beginning to come together, start shooting before the peak actually occurs. If you wait for the peak to start shooting you may miss the moment.

- When photographing sports such as baseball, football, tennis, basketball, or soccer try to include the ball in the photo.

- It helps if you're familiar with the action you're photographing. For instance, if you know how the game is played or where the race is going you'll have a better chance at anticipating and capturing the action.

- Last but not least a background that isn't distracting will help keep the attention on your subject. However, there's a lot to think about already so first focus on getting a sharp picture and capturing those peak moments.

Anticipate when the peak of action will occur and use a fast shutter to freeze the action.

PRODUCTS

One of the most important things for product photography is to make the product look good.

- Make sure the product is in good condition.
- Find a background that is not distracting. A solid colored background works very well.
- A basic black or white background is a good choice. Color of your product will dictate whether a dark or light background is better.
- Light the product with evening lighting. Harsh lighting is an unattractive way to present a product.
- You can purchase a light tent which is a box made out of translucent fabric. One side is open and you place a background material inside, then set your product in the box. Then set up lights to shine through the fabric sides. This produces a soft, even light over your subject.
- You can create a simple setup that doesn't take up much space. It doesn't have to be expensive and can produce high quality results.

The black backdrop nicely sets off the light colored bottles.

Part 6

Accessories

FLASH UNITS

Nikon makes external flash units that fit into the accessory shoe ("hot shoe") on top of the D60. The Speedlight SB-400 is a compact flash unit. It fits nicely with the size of the D60. The head of the SB-400 can be rotated upward 90 degrees to point toward the ceiling. This enables the use of bounce-flash. If you're looking for a more powerful flash than the D60's built-in flash the SB-400 is a good option. Nikon also makes larger flash units, the SB-800 and SB-600. These units are larger and are about the same size as the D60 itself. They offer a more powerful flash, custom settings, and the ability to use multiple flash units wirelessly.

The D60 comes with a cover over the accessory shoe. This needs to be removed to attach an external flash unit. Slide the cover toward the back of the camera to remove it. It's fitted in the accessory shoe quite tightly so it doesn't slide out very easily. If you're not using an external flash you can leave the cover in place.

REMOTE CONTROL

The ML-L3 remote (not included with the D60) is used to take pictures in the Delayed Response and Quick Response shooting modes. Nikon's specifications state that you shouldn't be more than 16 feet away from the camera when using the remote. However, I had no problem using the remote 24 feet away from the camera. Even though it's also recommend you

point the remote at the infrared receiver on the front of the camera, the remote will work when held behind the camera. Just have the front of the remote pointing at the back of the camera. If this doesn't happen to work you can always reach your hand around so the remote is pointing toward the front of the camera.

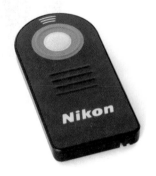

FILTERS

There are two filters I recommend you consider: UV/skylight and a polarizer.

UV/SKYLIGHT

The UV/Skylight filter is a clear filter whose main purpose is protecting the front of your lens. You might see some packaging or promotional information that says how these filters will improve the colors in your photos. If they do I don't think it's in any appreciable amount. If you buy one for your lens do it for protection, not to improve your photos. There is no requirement to use one, just personal preference. If you're photographing at the beach where salt spray is likely to get on the front of your lens you should use a UV filter even if you don't normally use one. The salt spray can be damaging to the coating on your lens.

POLARIZER

I think the polarizer is the most important all around filter if you're taking outdoor/nature photographs. You'll want to get a circular polarizer, not a linear one. A polarizer is made up of two pieces of glass and you rotate the front of the polarizer to adjust the amount of polarization. Polarizers can significantly improve your photo in certain situations.

Polarizers can reduce or remove the glare and reflection from many surfaces. Outside you'll find it takes glare off water (lakes, rivers), wet surfaces, and waxy foliage. It'll even do the same for a car hood or a shiny table. When it removes the glare it appears to increase saturation because the colors look richer. It's not actually adding saturation. When you see leaves, for instance, with a glossy surface their color is a little washed out. By removing the glare the true color is visible.

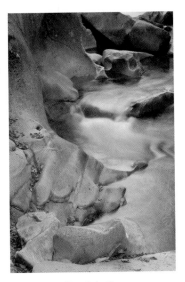 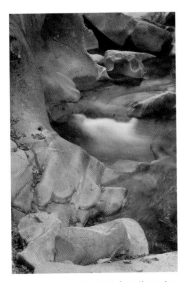

No polarization

Polarizers remove the glare from the water.

Polarizers can also darken blue skies depending on the angle to the sun. A polarizer will have the greatest effect on the sky when pointed at 90 degrees to the sun. It will have no effect when pointed directly at the sun or directly opposite the sun. As you turn the polarizer you'll see the blue in the sky darken. The darkening of the blue will also make clouds stand out better. At high elevations and in the southwestern area of the United States it's possible to over polarize and make the sky unnaturally dark, almost black. In these situations you can still use a polarizer, just don't turn it to its maximum amount of darkening.

No polarization.

Polarizers can darken a blue sky.

VIEWFINDER ACCESSORIES

Diopter Adjustment Viewfinder Lenses: At the beginning of the book I described how to set the diopter so that the markings in the viewfinder appeared sharp. If you were unable to correctly set the diopter for your eyesight there are additional diopter lenses you can purchase so that you correctly set the diopter for your eyes.

Eyepiece Magnifier DG-2: This accessory magnifies what is seen at the center of the viewfinder. It requires the DK-22 adapter to connect it to the D60.

Right Angle Viewing Attachment DR-6: The right angle viewing attachment attaches to the viewfinder eyepiece and sticks straight up. It allows you to see through the viewfinder from just above the top of the camera. This accessory is most useful when you're photographing close to the ground. If the D60 is on a tripod right near the ground you may have to lie down on the ground to see through the viewfinder. The right angle attachment would allow you to look down into the viewfinder from a kneeling position.

VIDEO CABLE

Use the EG-D100 video cable to connect the D60 to a TV or VCR.

POWER ADAPTER

You can purchase a power adapter for the D60 that enables you to power the camera by plugging it into an outlet. The main use for this would be if you're photographing in a studio or other indoor location where you won't need to move around much. For the D60 you need two pieces of equipment:

1. Power Connector EP-5
2. AC Adapter EH-5a

It's necessary to have these two items because the D60 doesn't have an AC power port. You insert the Power Connector into the battery compartment (battery is taken out) then connect the AC Adapter to the Power Connector.

Corey Hilz

www.coreyhilz.com

Author's Web site including an online glossary companion to the book.

Nikon

http://nikonusa.com/

Nikon's Web site for the United States.

Nikonians

http://www.nikonians.org/

Online community of Nikon photographers. Gear information, reviews, forums, and more.

Photo.net

http://photo.net/

Online photo community.

Flickr

http://www.flickr.com/

See the photos of others and share your work. Online photo albums and organization tools available.

Rob Galbraith Digital Photography Insights

http://robgalbraith.com/

Photo industry news.

Digital Photography Review

http://dpreview.com/

Detailed product reviews, product announcements, and photo industry news.

Outdoor Photographer Magazine

http://www.outdoorphotographer.com/

Photo tips, information about gear, and where to go to photograph.

Popular Photography

http://www.popphoto.com/

Product information, reviews, how-to information, and more.

Nik Software

http://www.niksoftware.com/

Software plug-ins for Photoshop and Photoshop Elements. Includes software for sharpening, noise reduction, and filter sets.

Visible Dust

http://visibledust.com/

Products for cleaning your sensor.

Lensbabies

http://lensbabies.com/

Selective focus lenses for SLR cameras.

Index